D0890479

Cover: Odilon Redon, No. 66

Copyright © 1980 by The Metropolitan Museum of Art

ISBN 0-87099-256-2

Published by The Metropolitan Museum of Art
Bradford D. Kelleher, Publisher
John P. O'Neill, Editor in Chief
Polly Cone, Editor
Doris L. Halle, Adrienne Burk, Designers

19th Century French Drawings

FROM THE ROBERT LEHMAN COLLECTION

CATALOGUE BY
GEORGE SZABO

The Metropolitan Museum of Art
New York
1980

INTRODUCTION

This exhibition of nineteenth-century French drawings continues the series that will eventually bring all the drawings in the Robert Lehman Collection to public view.

Among these eighty-five sheets are drawings in various media, including watercolor, representing the most important French masters of the century as well as lesser-known French artists. Important groups of portraits by Ingres and Chassériau demonstrate the high standards of draftsmanship in force at the beginning of the century. The landscape drawings by the masters of the Barbizon School comprise another outstanding assembly. Boudin and Rousseau are especially well represented among the Barbizon sheets, the former with an unusual large landscape in variations of gray. Drawings by the Impressionists are again outstanding: the groups by Renoir and Degas and important single sheets by such artists as Bazille, Morisot, and Pissarro form the greatest part of the exhibition. The black-and-white studies of Seurat and Redon and a group of radiant watercolors by Cross complete this survey of nineteenth-century draftsmanship in France.

The catalogue is restricted to giving the basic information on each drawing. In addition, unpublished versos are reproduced here for the first time. The bibliographies are short and limited to catalogues raisonnés and basic publications.

The exhibition and catalogue have been prepared by the staff of the Robert Lehman Collection. Conservation and matting have again been done by the Department of Paper Conservation.

The design for the poster, catalogue, and labels was the responsibility of the Design Department, whose collaboration is gratefully acknowledged here.

George Szabo
Curator
Robert Lehman Collection

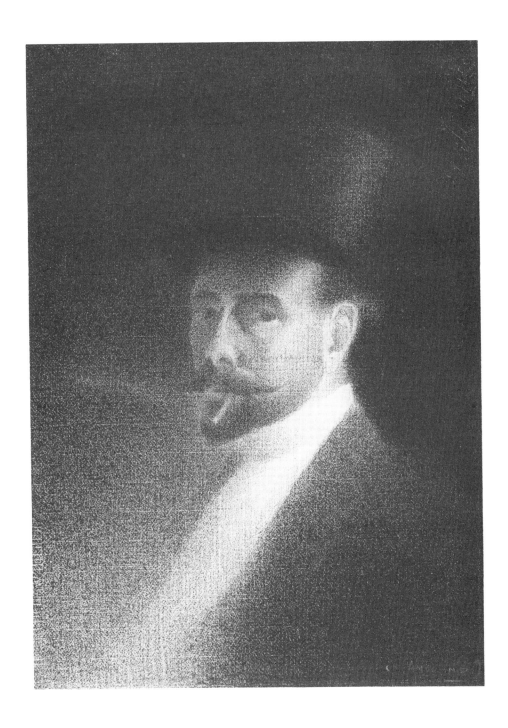

CHARLES ANGRAND, Rouen, Paris, 1854–1926

1. *Self-Portrait*

Conté crayon on paper, 61 x 44.5 cm. Signed and dated in lower right corner: *Ch.Angrand.92.*

BIBLIOGRAPHY: J. Rewald, *Post-Impressionism from Van Gogh to Gauguin*, New York, 1956, p. 431; Cincinnati, no. 290; R. L. Herbert, *Neo-Impressionism*, New York, 1968, no. 6; *Paris: Places and People*, no. 36.

This virtuoso self-portrait demonstrates the artist's superb use of the medium, which results in a velvety chiaroscuro. This is in deliberate contrast to the flat tones used by some of Angrand's contemporaries among the Nabis. As to the formal attire, Herbert remarks, "The elegance professed...a witty counterpoint to the bohemianism of many...friends."

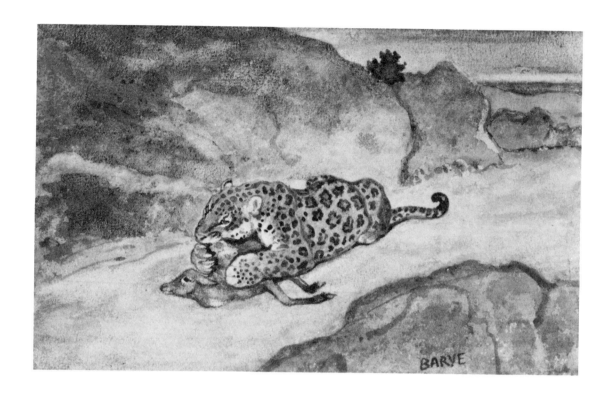

ANTOINE-LOUIS BARYE, Paris, 1796–1875

2. Tiger Devouring a Gazelle

Watercolor on paper, 14 x 23.5 cm. Signed at lower right: *BARYE*.

BIBLIOGRAPHY: École des Beaux-Arts, *Exposition Barye*, Paris, 1889, no. 741; Galerie Alfred Daber, *L'Univers de Barye*, exhibition catalogue, Paris, 1956, no. 12.

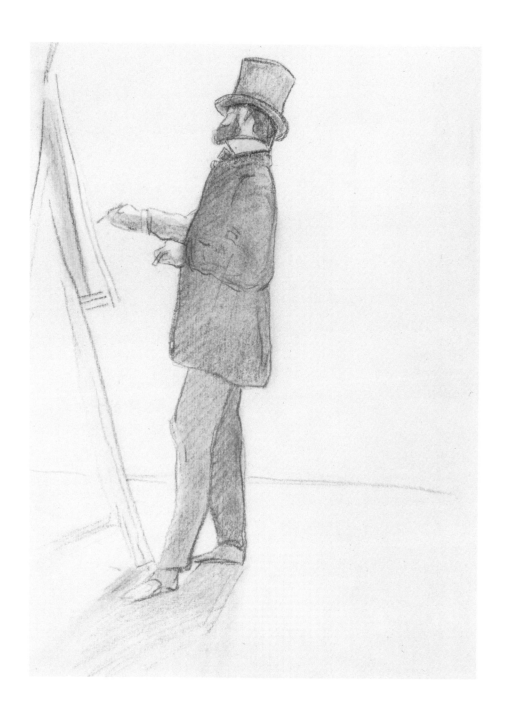

FRÉDÉRIC BAZILLE, Montpellier, Paris, Beaune-la-Rolande, 1841–1870

3. *Manet at His Easel*

Charcoal on paper, 29.5 x 21.5 cm.

BIBLIOGRAPHY: F. Daulte, *Frédéric Bazille et son temps*, Geneva, 1952, no. 24, p. 197; *Tricolour*, no. 52; Art Institute of Chicago, *Frédéric Bazille and Early Impressionism*, exhibition catalogue, Chicago, 1978, no. 35.

Bazille, a talented and promising young painter, was one of the early proponents of Impressionism. His career was cut short by his untimely death in the Franco-Prussian War. His drawings, therefore, are rare, especially such ambitious ones as this. Judging from Manet's apparent age here, the drawing was probably done around 1869 (See J. P. Bouillon, "Manet vu par Bracquemond," *Revue de l'Art* 27 (1975), pp. 37–44).

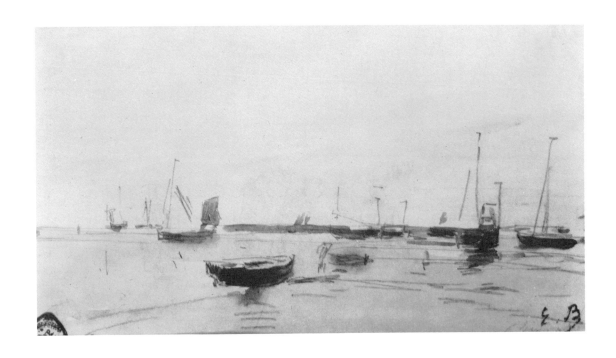

EUGÈNE-LOUIS BOUDIN, Honfleur, Paris, 1824–1898

4a. *Marine Scene*

Watercolor on paper, 13.3 x 23 cm. Signed with initials in lower right corner: *E.B.* On the verso:
No. 4b.

BIBLIOGRAPHY: *Tricolour,* no. 61; Cincinnati, no. 279.

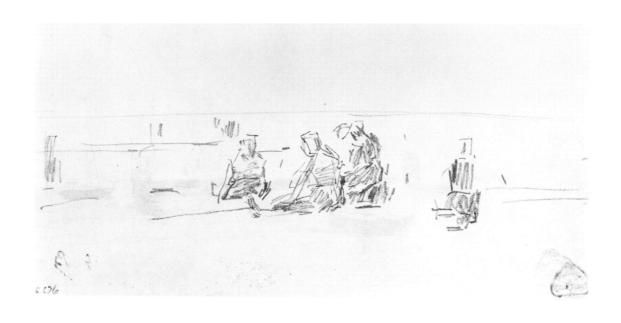

EUGÈNE-LOUIS BOUDIN, Honfleur, Paris, 1824–1898

4b. *Figures on the Beach*

Pencil on paper, 13.3 x 23 cm. Verso of No. 4a.

BIBLIOGRAPHY: *Tricolour,* no. 61.

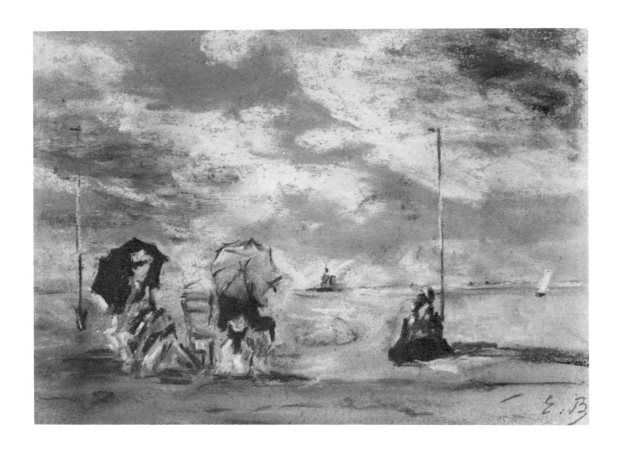

EUGÈNE-LOUIS BOUDIN, Honfleur, Paris, 1824–1898

5. *Beach Scene*

Pastel on paper, 14.6 x 20.3 cm. Signed with initials in lower right corner: *E.B.*

Unpublished.

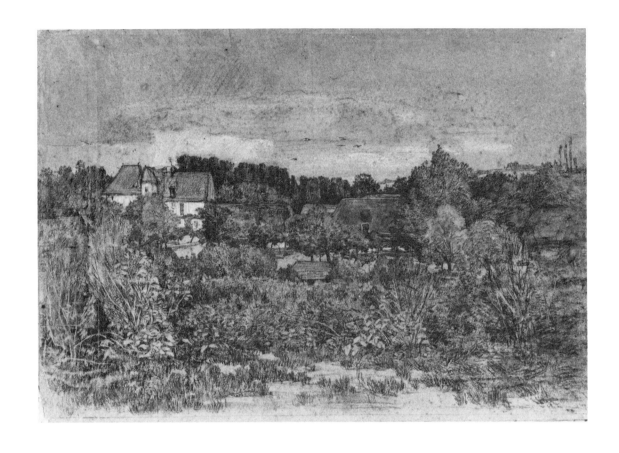

EUGÈNE-LOUIS BOUDIN, Honfleur, Paris, 1824–1898

6. *Landscape*

Black chalk on gray paper heightened with white chalk, 40 x 57 cm.

BIBLIOGRAPHY: *Tricolour,* no. 60.

This is an unusual drawing by an artist well known for works like the two previous drawings, light and colorful beach scenes of Trouville and Deauville in Normandy.

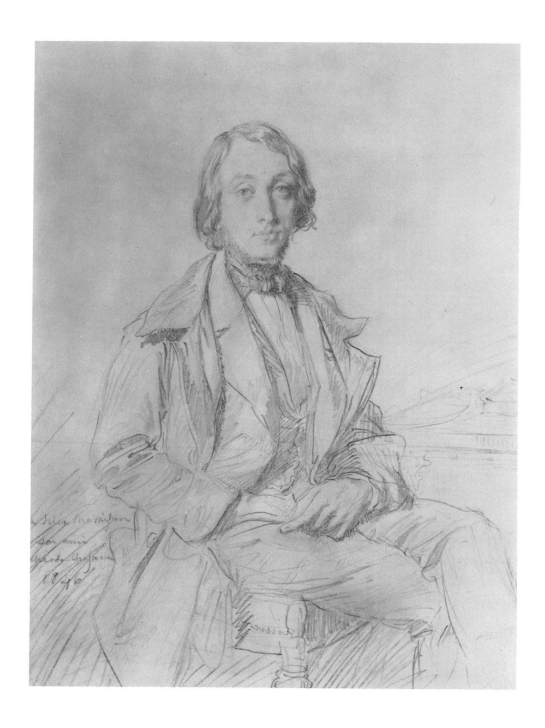

THÉODORE CHASSÉRIAU, Samana (Santo Domingo), Paris, 1819–1856

7. Portrait of Félix Ravaisson

Pencil on paper, 33.3 x 25.4 cm. Inscribed and signed by the artist in lower left corner: *à Félix Ravaisson son ami Théodore Chassériau 1846.*

BIBLIOGRAPHY: V. Chevillard, *Un Peintre romantique, Théodore Chassériau*, Paris, 1893, p. 305, no. 291; L. Bénédite, *Théodore Chassériau, sa vie et son oeuvre*, vol. II, Paris, 1931, p. 362; *Tricolour,* no. 62.

Félix Lacher Ravaisson-Mallien (1813–1900) was a well-known philosopher and archaeologist. The year this drawing was made, he was awarded a prize by the French Academy for his *Essay on the Metaphysics of Aristotle.* Ravaisson also published several articles on art, including one on the Venus de Milo and another on drawings.

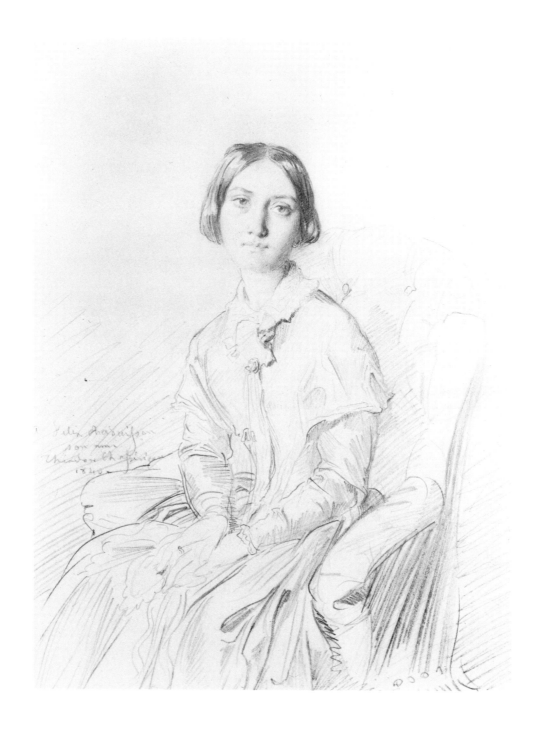

THÉODORE CHASSÉRIAU, Samana (Santo Domingo), Paris, 1819–1856

8. *Portrait of Madame Ravaisson*

Pencil on paper, 33.3 x 25.4 cm. Inscribed and signed by the artist in lower left corner: *A Félix Ravaisson son ami Théodore Chassériau 1846.*

BIBLIOGRAPHY: L. Bénédite, *Théodore Chassériau, sa vie et son oeuvre*, Paris, vol. II, 1931, p. 362; *Tricolour,* no. 63.

These two portraits remained in the family of the sitters until acquired by Wildenstein and Co. in 1961.

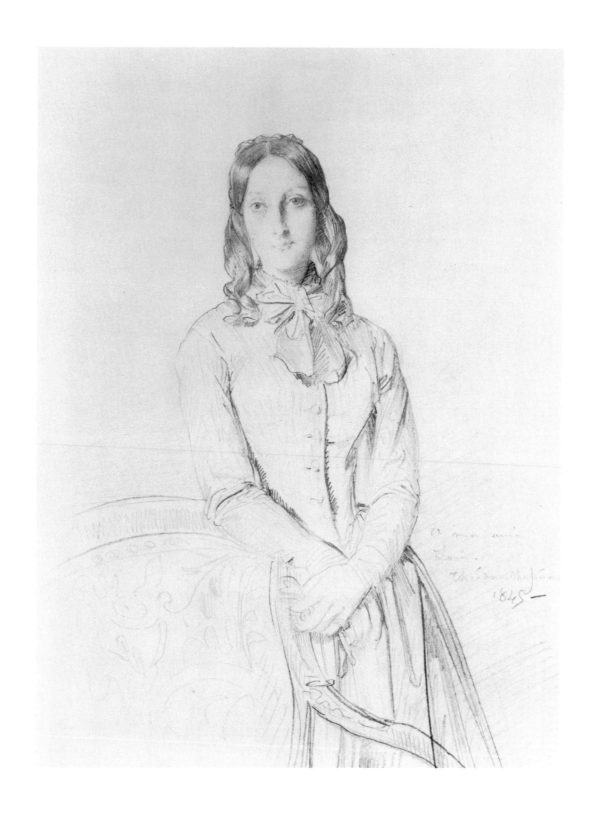

THÉODORE CHASSÉRIAU, Samana (Santo Domingo), Paris, 1819–1856

9. *Portrait of Madame Gabrielle Marcotte de Quivières*

Pencil on paper, 32.5 x 27.3 cm. Inscribed and signed by the artist in lower right corner: *A mon ami Louis. Théodore Chassériau 1845–.*

BIBLIOGRAPHY: V. Chevillard, *Un Peintre romantique, Théodore Chassériau*, Paris, 1893, no. 308.

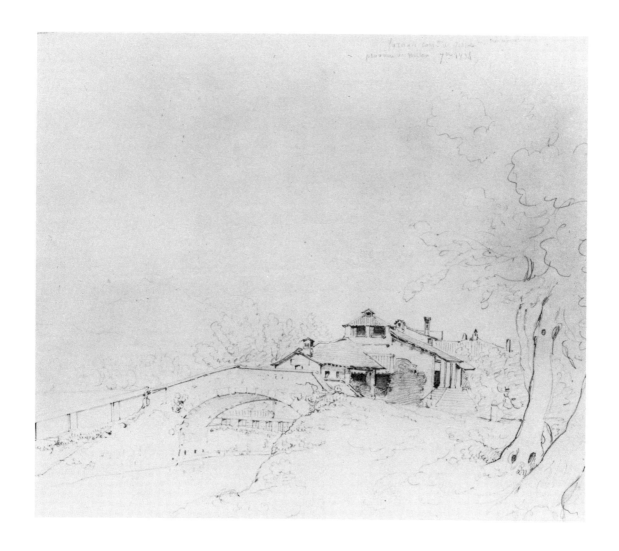

JEAN-BAPTISTE-CAMILLE COROT, Paris, 1796–1875

10. *Province de Milan*

Pencil on paper, 21 x 24.8 cm. Inscribed by the artist in upper right corner: *fornace com. a Gelloli province de Milan 7 au 1834.*

BIBLIOGRAPHY: *Tricolour,* no. 65.

This rapid topographic sketch was done on August 7, 1834, during the artist's second journey to Italy (D. Baud-Bovy, *Corot*, Geneva, 1957, pp. 84–85).

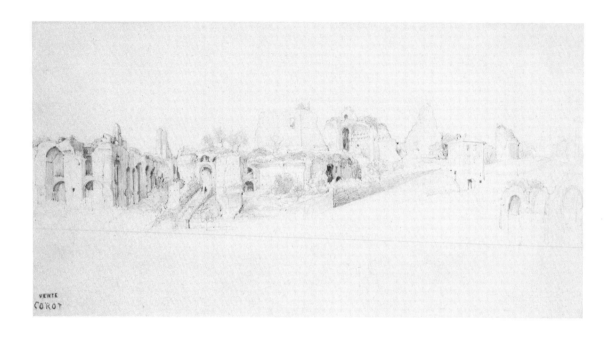

JEAN-BAPTISTE-CAMILLE COROT, Paris, 1796–1875

11. *Rome—The Palatine Hill*

Pencil on buff paper, 19 x 36.8 cm. Stamped with the mark of the artist's studio sale: *Vente Corot*.
Unpublished.

This drawing is probably from around 1843, when the artist made his third trip to Italy
(D. Baud-Bovy, *Corot*, Geneva, 1957, p. 86). The studio sale of Corot's drawings was held on
May 31, 1875, three months after his death.

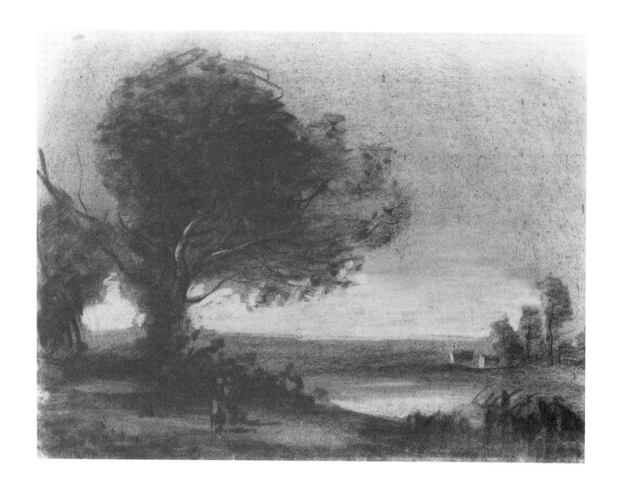

JEAN-BAPTISTE-CAMILLE COROT, Paris, 1796–1875

12. *Landscape*

Charcoal on buff paper, 33 x 42.5 cm. Inscribed by the artist in charcoal in lower left corner: *COROT.*

BIBLIOGRAPHY: *Tricolour,* no. 64.

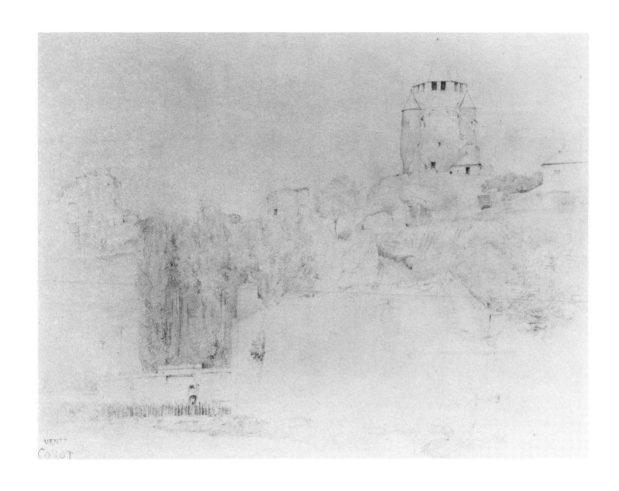

JEAN-BAPTISTE-CAMILLE COROT, Paris, 1796–1875

13. *View of Provins*

Pencil on paper, 22.1 x 29.2 cm. Stamped with the mark of the artist's studio sale: *Vente Corot*.
Unpublished.

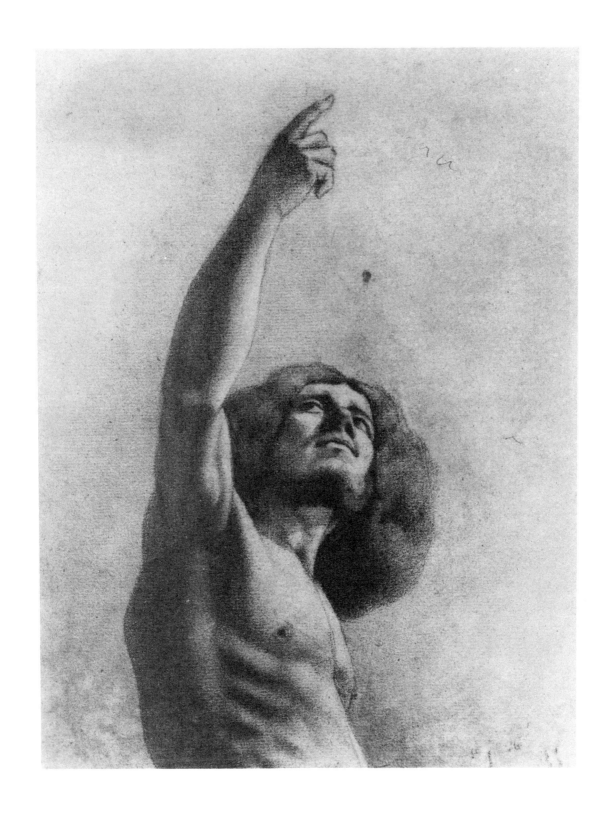

GUSTAVE COURBET, Ornans, Paris, La Tour de Peilz, 1819–1877

14. *Figure of a Man*

Pencil on paper, 26.7 x 19.7 cm.

BIBLIOGRAPHY: Anderson Galleries, *Etchings, Lithographs, Original Drawings, The Collection of Marius de Zayas*, New York, May, 1920, no. 176; *Tricolour,* no. 66.

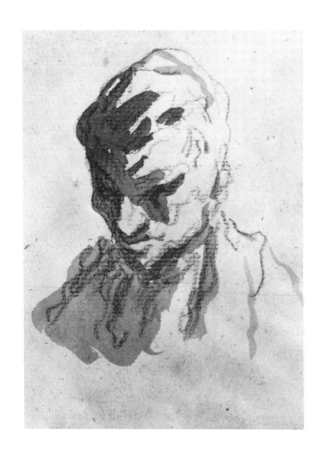

HONORÉ DAUMIER, Paris, 1808–1879

15. *Head of a Man Turning to the Right*

Charcoal and wash on paper, 10.4 x 8.3 cm.

BIBLIOGRAPHY: Maison, *Daumier*, vol. II, no. 24, pp. 30–31; *Tricolour*, no. 68.

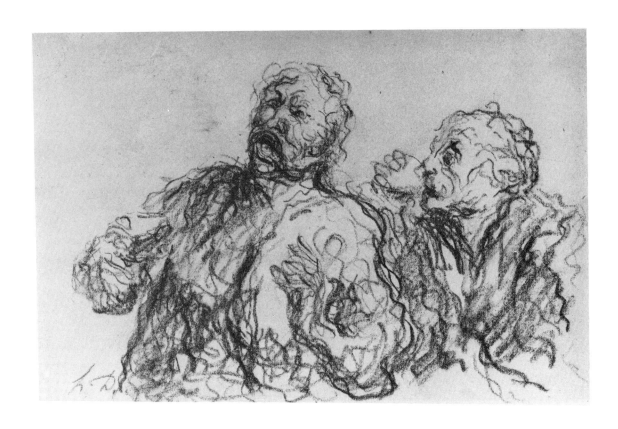

HONORÉ DAUMIER, Paris, 1898–1897

16a. *Two Drinkers*

Black chalk on paper, 15 x 23.2 cm. Inscribed with the artist's monogram in lower left corner: *h.D.* On the verso: No. 16.

BIBLIOGRAPHY: Musée Cognacq-Jay, *Daumier,* exhibition catalogue, Paris, 1961, no. 4; Palais Galliera, *Collection René G.-D.*, Paris, June, 1966, no. 7; Maison, *Daumier*, vol. II, p. 113; *Tricolour,* no. 70; R. Passeron, *Daumier, Témoin de son temps*, Paris, 1979, p. 275, fig. 208.

R. Passeron feels that this drawing is incontestably by Daumier despite the reservations expressed by Maison.

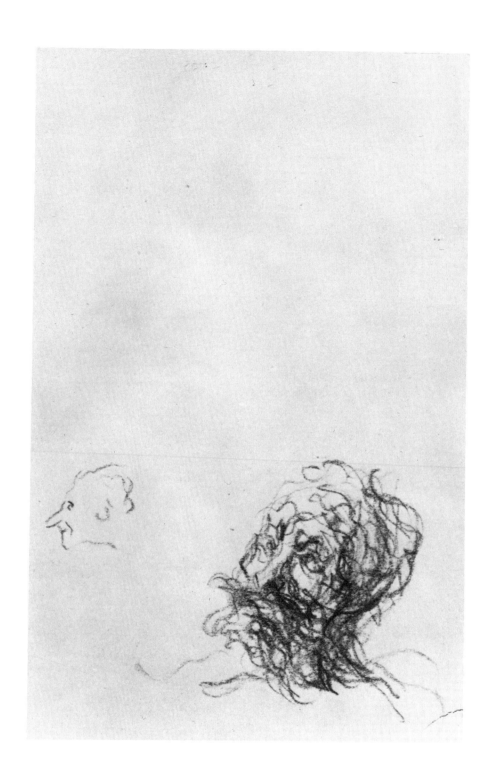

HONORÉ DAUMIER, Paris, 1880–1879

16b. *Two Heads*

Crayon on paper, 15 x 23.2 cm. Verso of No. 16.a.

BIBLIOGRAPHY: Palais Galliera, *Collection René G.-D.*, Paris, June, 1966, no. 7; *Tricolour*, no. 70.

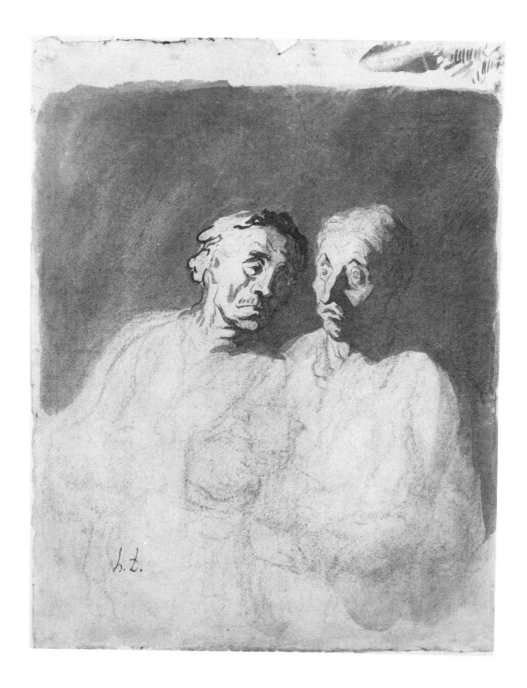

HONORÉ DAUMIER, Paris, 1808–1879

17. *Two Drinkers*

Pen and brush with wash over charcoal on paper, 32 x 24.5 cm. Signed with initials in lower left corner: *h.D.* Trial pen- and brushstrokes in upper right corner of sheet.

BIBLIOGRAPHY: Palais Galliera, *Collection René G.-D.*, Paris, June, 1966, no. 8; Maison, *Daumier,* vol. II, no. 316; The Metropolitan Museum of Art, *Classicism and Romanticism, French Drawings and Prints 1800–1860*, exhibition catalogue, New York, 1970, no. 7; R. Passeron, *Daumier, Témoin de son temps*, Paris, 1979, p. 278, fig. 211.

The drinkers are a favorite subject of the artist (see No. 16a). The present drawing is also interesting because it shows how the composition and the tonal values were developed from the first charcoal sketch, as in the unfinished lower part, to the strongly contrasting darks and lights in the upper half.

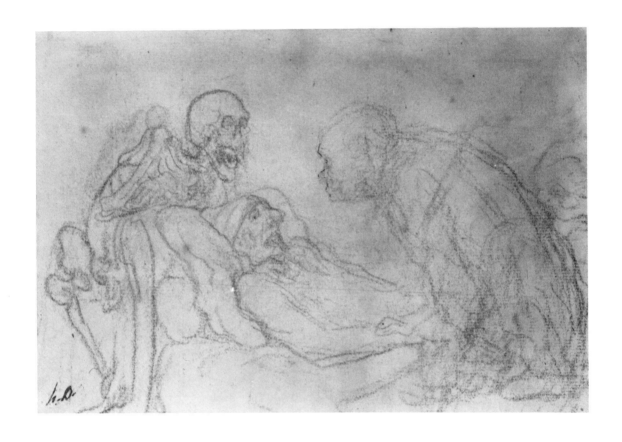

HONORÉ DAUMIER, Paris, 1808–1879

18. *Death and the Doctor*

Black chalk on paper, 14.2 x 21.5 cm. Inscribed with the artist's monogram in lower left corner: *h.D.*

BIBLIOGRAPHY: M. Gauthier, *Daumier*, Paris, n.d., pl. 60; Musée Cognacq-Jay, *Daumier*, exhibition catalogue, Paris, 1961, no. 6; Palais Galliera, *Collection René G.-D.*, Paris, June, 1966, no. 10; Maison, *Daumier*, vol. II, no. 402; *Tricolour*, no. 69; R. Passeron, *Daumier, Témoin de son temps*, p. 192, fig. 123.

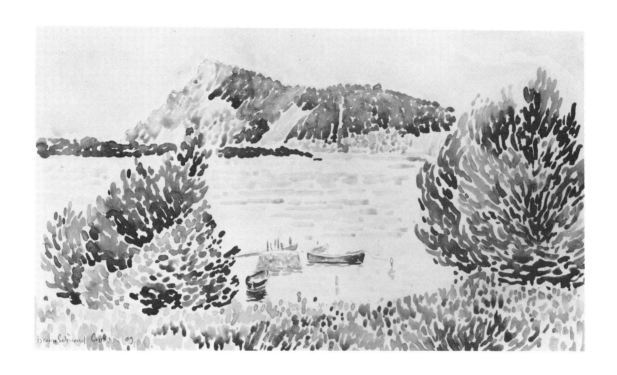

HENRI-EDMOND DELACROIX, called CROSS, Douai, Paris, St.-Clair, 1856–1910

19. *The "Cap Nègre"*

Watercolor over pencil on paper, 22 x 38 cm. Dated and signed in pencil in lower left corner: *Henri Edmond Cross 09.*

BIBLIOGRAPHY: Galerie Charpentier, *Collection de Madame S… Tableaux modernes,* Paris, May, 1952, no. 2; Compin, *Cross,* p. 345, fig. T.

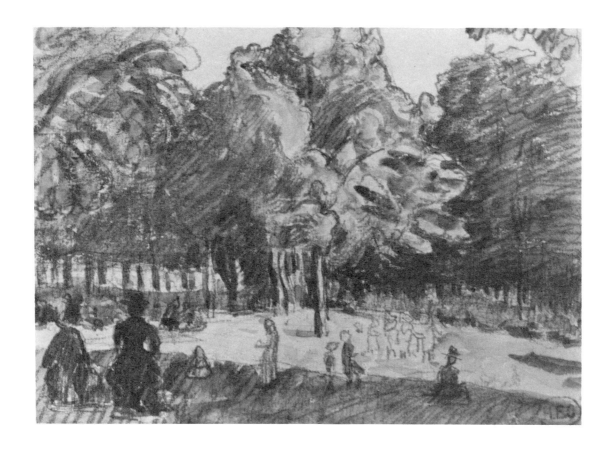

HENRI-EDMOND DELACROIX, called CROSS, Douai, Paris, St.-Clair, 1856–1910

20. *Study for the painting "Le Ranelagh"*

Pencil and crayon with watercolor on paper, 12 x 16.5 cm. In lower right corner studio stamp: *H.E.C.*

BIBLIOGRAPHY: Galerie Charpentier, *Collection de Madame S… Tableaux modernes*, Paris, May, 1952, no. 10; Compin, *Cross*, pp. 170, 341, fig. F; *Paris: Places and People*, no. 13.

Formerly titled *Parc de la Muette*, this drawing is identified by Compin as a study for Cross's well-known painting *Le Ranelagh*, begun in 1899 and signed and dated in 1900.

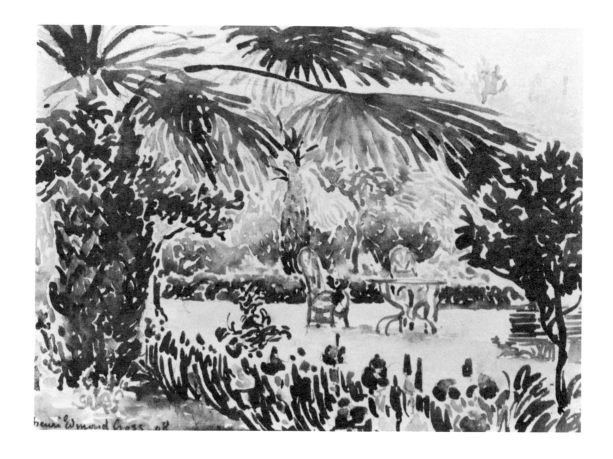

HENRI-EDMOND DELACROIX, called CROSS, Douai, Paris, St.-Clair, 1856–1910

21. *The Garden of the Painter in St.-Clair*

Watercolor over pencil on paper, 17.1 x 24.1 cm. Signed and dated by the artist in pencil in lower left corner: *Henri Edmond Cross. 08.*

BIBLIOGRAPHY: Fine Arts Associates, *Henri-Edmond Cross*, exhibition catalogue, New York, 1951, no. 2; Cincinnati, no. 291; Compin, *Cross*, p. 344; fig. 0.

Although this watercolor was painted in 1908, it reflects the artist's predominant style of the last decades of the nineteenth century. Most of the watercolors by Cross in this exhibition are from the same late period.

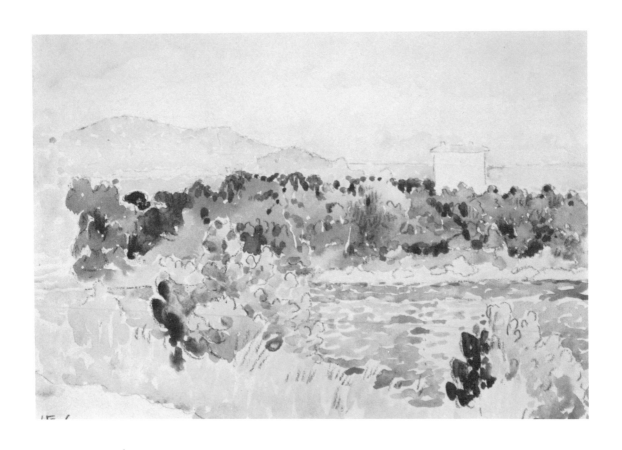

HENRI-EDMOND DELACROIX, called CROSS, Douai, Paris, St.-Clair, 1856–1910

22. *Landscape with a Town*

Watercolor over pencil on paper, 17.3 x 24.9 cm. Signed in lower left corner: *HE.C.*

BIBLIOGRAPHY: Cincinnati, no. 292; *French Watercolor Landscapes*, no. 35.

This watercolor was probably painted in the first decade of the twentieth century.

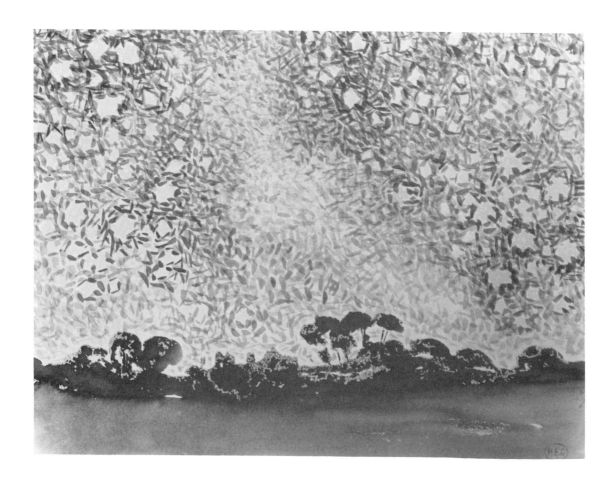

HENRI-EDMOND DELACROIX, called CROSS, Douai, Paris, St.-Clair, 1856–1910

23. *Landscape with Stars*

Watercolor over pencil on paper, 20.5 x 32.5 cm. Stamped with studio stamp in lower right corner: *H.E.C.*

BIBLIOGRAPHY: Galerie Charpentier, *Collection de Madame S… Tableaux modernes*, Paris, May, 1952, no. 6; Compin, *Cross*, p. 343, fig. K; *French Watercolor Landscapes*, no. 33.

In her catalogue raisonné, Isabelle Compin places this striking aquarelle among those dated around 1906. A recent catalogue contains this observation: "The unique style and technique of *Landscape with Stars* make it difficult to place chronologically within Cross's oeuvre. The shadowy wash landscape is set against the divided bright blues and yellows of the starry sky, unusually combining two aspects—the decorative and the scientific" (*French Watercolor Landscapes*, p. 95).

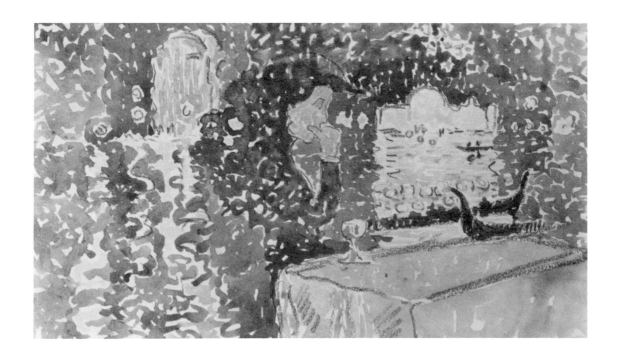

HENRI-EDMOND DELACROIX, called CROSS, Douai, Paris, St.-Clair, 1856–1910

24. *Venice—Night of the Festival of the Redeemer*

Watercolor over pencil on paper, 13.9 x 24.3 cm. Inscribed in pencil by the artist on verso: *Souvenir… sta da Redentore venize 18 juillet.*

BIBLIOGRAPHY: Galerie Charpentier, *Collection de Madame S… Tableaux modernes*, Paris, May, 1952, no. 12.

This unusual composition reflects the artist's experiences during his trip to Venice in 1903. Its pensive air and the vibrant reflections seem to illustrate the thoughts he jotted down in his journal: "Venise admirable… Toutes les nuances depuis la gravité assise jusqu'à la plus inepte frivolité. Et l'architecture admirablement variée et vivante est comme le prolongement vers le ciel de cette vie intense, de ce maximum de vie donné par les canaux plus l'eau adorable et ses reflets infinis!" (Compin, *Cross*, p. 208).

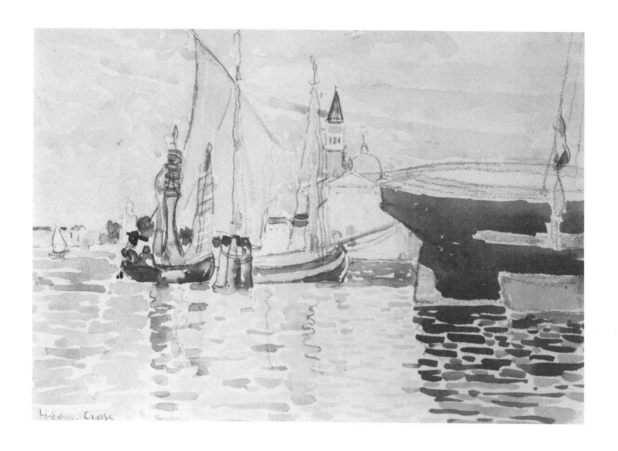

HENRI-EDMOND DELACROIX, called CROSS, Douai, Paris, St.-Clair, 1856–1910

25. *Venice—The Giudecca*

Watercolor over pencil on paper, 17 x 25 cm. Signed in pencil in lower left corner: *H. Edm. Cross.*

BIBLIOGRAPHY: Galerie Charpentier, *Collection de Madame S… Tableaux modernes*, Paris, May, 1952, no. 5.

This and the other watercolors of Venetian subjects must have been painted during the artist's stay in Venice in July and August of 1903. A view of the same subject on canvas was exhibited in 1904 at the Salon des Independants (Compin, *Cross*, pp. 220–21).

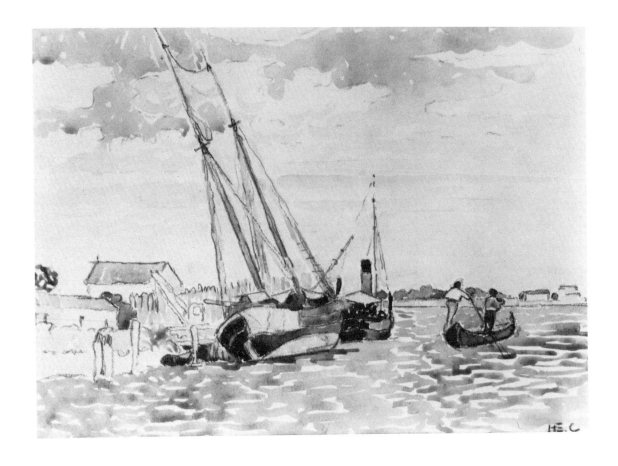

HENRI-EDMOND DELACROIX, called CROSS, Douai, Paris, St.-Clair, 1856–1910

26. *Marine Scene*

Watercolor over pencil on paper, 17.1 x 24.1 cm. Signed in lower right corner: *HE.C.*

Unpublished.

This aquarelle is probably from the time of the artist's trip to Venice in 1903 or shortly thereafter.

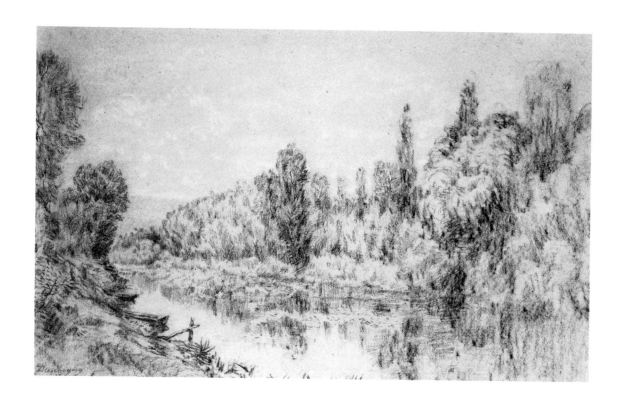

CHARLES-FRANÇOIS DAUBIGNY, Paris, 1817–1878

27. *Landscape with Pond*

Black crayon heightened with white on paper, 28.9 x 43.8 cm. Signed in lower left corner: *Daubigny.*
Unpublished.

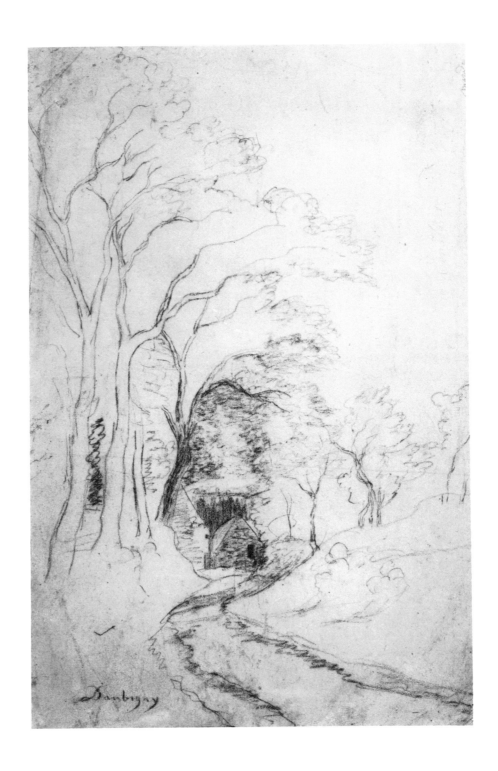

CHARLES-FRANÇOIS DAUBIGNY, Paris, 1817–1878

28a. Country Road

Black crayon on paper heightened with white, 42.2 x 25.6 cm. Signed in lower left corner: *Daubigny.* In upper right corner an illegible crayon inscription of several lines beginning with the word *Constant.* On the verso: No. 28b.

BIBLIOGRAPHY: *Tricolour,* no. 67.

Even in this fleeting drawing, Daubigny demonstrates his acute awareness of natural light and form. Although undated, the work is probably from the early 1870s.

CHARLES-FRANÇOIS DAUBIGNY, Paris, 1817–1878

28b. *Landscape with Trees*

Crayon on paper, 42.2 x 25.6 cm. Verso of No. 28a.

Unpublished.

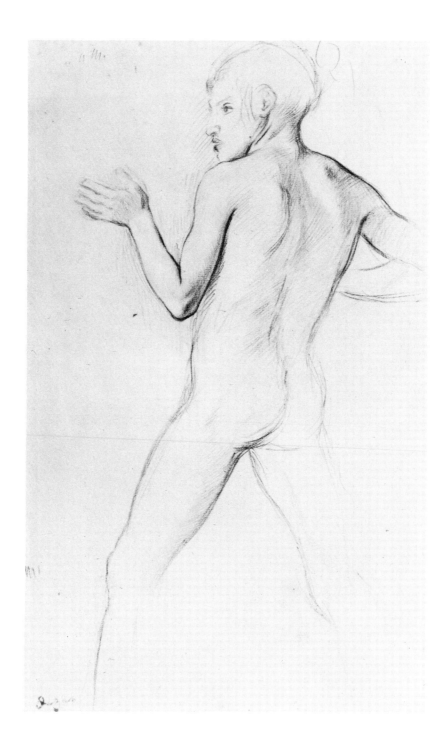

EDGAR-HILAIRE-GERMAIN DEGAS, Paris, 1834–1917

29. *Youth in an Attitude of Defense*

Pencil on paper, 34.3 x 21.3 cm. Stamped at lower left: *Degas*. Also stamped on the verso: *Atelier Ed. Degas*.

BIBLIOGRAPHY: Galerie Georges Petit, *Vente Atelier Degas*, May, 1919, no. 62b(?); Cincinnati, no. 282; D. Burnell, "Degas and His 'Young Spartans Exercising,'" *The Art Institute of Chicago Museum Studies* 4 (1969), pp. 56–57; *Degas in the Metropolitan*, no. 5.

This is a study for the artist's painting *The Young Spartan Girls Provoking the Boys* in the National Gallery of Art, London. The drawing may be dated to around 1860.

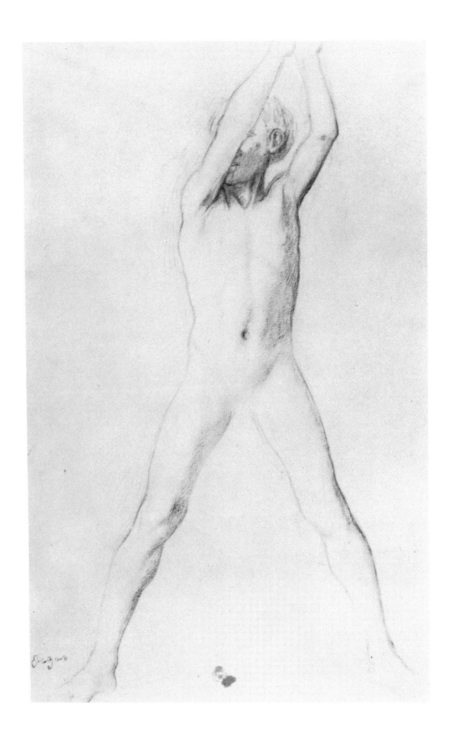

EDGAR-HILAIRE-GERMAIN DEGAS, Paris, 1834–1917

30. *Youth with Arms Upraised*

Pencil on paper, 31.7 x 19.4 cm. Stamped at lower left: *Degas*. Also stamped on the verso: *Atelier Ed. Degas*.

BIBLIOGRAPHY: Galerie Georges Petit, *Vente Atelier Degas*, Paris, May, 1919, no. 62b(?); Cincinnati, no. 283; D. Burnell, "Degas and His 'Young Spartans Exercising,'" *The Art Institute of Chicago Museum Studies* 4 (1969), pp. 56–57; *Degas in the Metropolitan*, no. 6.

Like the previous drawing, this is a study for an early historical painting, *The Young Spartan Girls Provoking the Boys*, now in the National Gallery of Art, London.

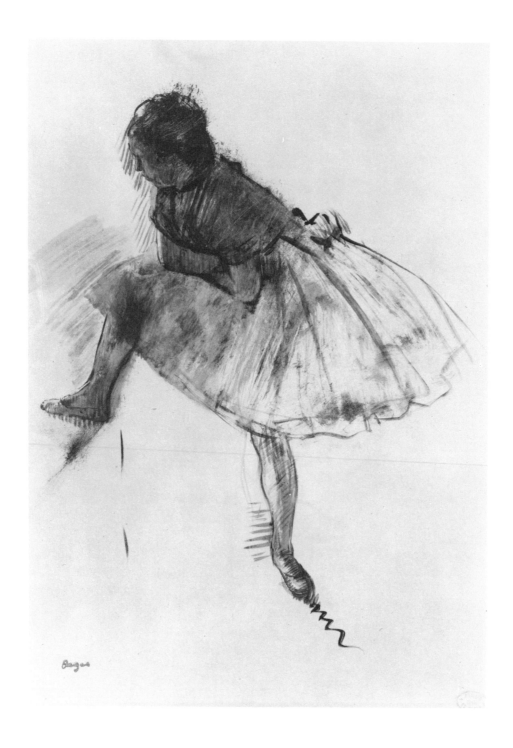

EDGAR-HILAIRE-GERMAIN DEGAS, Paris, 1834–1917

31a. *Sketch of a Ballet Dancer*

Oil colors mixed with turpentine and heightened with white on prepared pink paper, 44.5 x 31.4 cm. Stamped at lower left: *Degas*. Also an oval stamp at lower right: *Atelier Ed. Degas*. On the verso: No. 31b.

BIBLIOGRAPHY: Galerie Georges Petit, *Vente Atelier Degas*, Paris, December, 1918, no. 235; Paris, no. 133; Cincinnati, no. 281; *Degas in the Metropolitan*, no. 20.

This beautifully composed drawing is from the period of the artist's great ballet paintings. It is generally dated between 1874 and 1878.

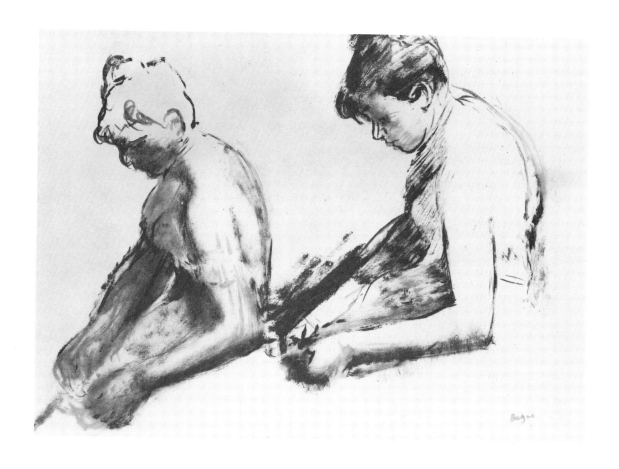

EDGAR-HILAIRE-GERMAIN DEGAS, Paris, 1834–1917

31b. *Sketches of a Ballet Dancer*

Oil colors mixed with turpentine on prepared pink paper, 31.4 x 44.5 cm. Stamped at lower right: *Degas*. Verso of No. 31a.

BIBLIOGRAPHY: Galerie Georges Petit, *Vente Atelier Degas*, Paris, December, 1918, no. 235; Paris, no. 133; Cincinnati, no. 281; *Degas in the Metropolitan*, no. 20.

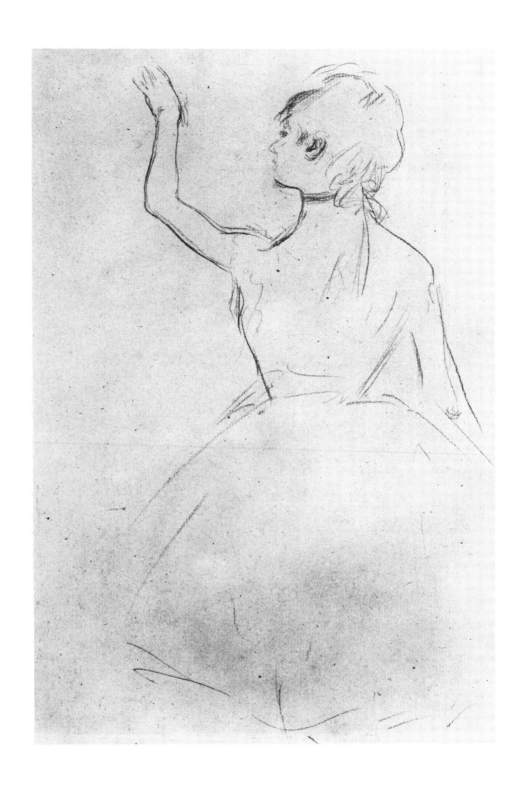

EDGAR-HILAIRE-GERMAIN DEGAS, Paris, 1834–1917

32. *Study of a Ballet Dancer*

Black chalk on paper, 31.7 x 21.8 cm. Stamped on the verso: *Atelier Ed. Degas*.

BIBLIOGRAPHY: *Tricolour,* no. 71; *Degas in the Metropolitan,* no. 32.

This quick sketch may be dated to around 1880.

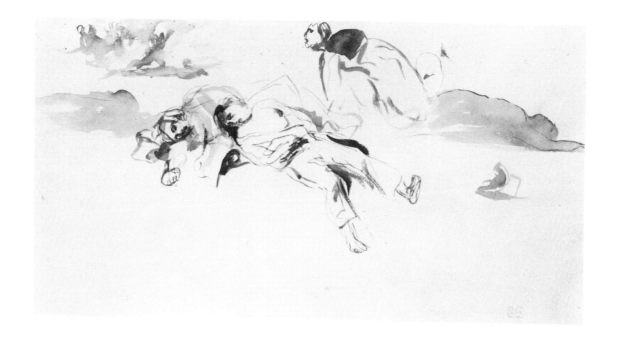

FERDINAND-VICTOR-EUGÈNE DELACROIX, Charenton, Paris, 1798–1863

33. *Study for "Liberty Leading the People"*

Point of brush and ink on paper, 17.8 x 33 cm. Stamped in lower right corner with studio stamp: *E.D.*

BIBLIOGRAPHY: R. Escholier, *Delacroix, peintre, graveur, écrivain*, vol. I, Paris, 1927, p. 267; *Tricolour*, no. 74.

This is a study for Delacroix's famous painting of the same title, painted in 1830 and purchased the same year by the French state. It was not exhibited in the Louvre until 1874. The drawing is probably from a sketchbook of ten pages, all representing the same subject and dated 1830 (A. Robault and E. Chesneau, *L'Oeuvre complet de Eugène Delacroix*, New York, 1969, no. 1558).

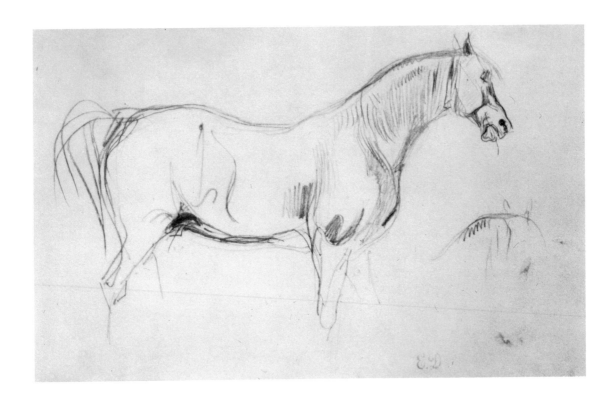

FERDINAND-VICTOR-EUGÈNE DELACROIX, Charenton, Paris, 1798–1863

34. *Studies of a Horse in Profile*

Pencil on paper, 14.3 x 22.5 cm. Stamped in lower right corner with studio stamp: *E.D.*

Unpublished.

This sensitive study of an English racing horse and its head belongs to a group of studies the artist made after English illustrations of horseraces and hunting scenes. Most of these are dated around 1830 (see W. Stechow, "Notes on a Drawing by Delacroix," *Miscellanea I. Q. van Regteren Altena*, Amsterdam, 1969, pp. 214–15).

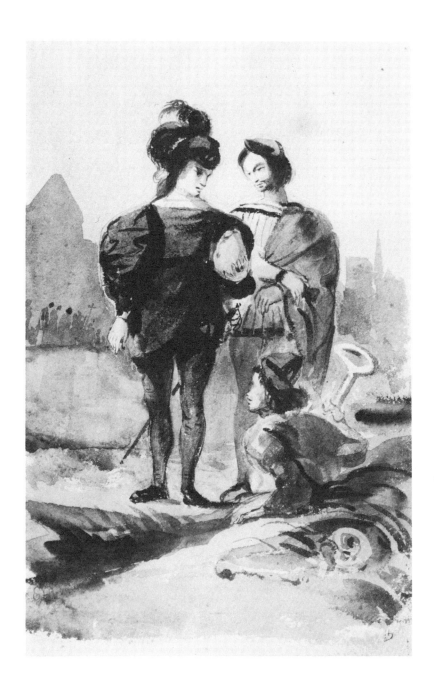

FERDINAND-VICTOR-EUGÈNE DELACROIX, Charenton, Paris, 1798–1863

35. *Hamlet and the Gravediggers*

Brush and brown wash with watercolor over pencil on paper, 27 x 18.1 cm. Stamped in lower left corner with studio stamp: *E.D.*

BIBLIOGRAPHY: R. Escholier, *Delacroix, peintre, graveur, écrivain*, vol. I, Paris, 1927, p. 202; *Tricolour,* no. 47.

This virtuoso composition is probably the best of Delacroix's studies for his paintings of 1839 and 1859 and for the well-known lithograph of this Shakespearean subject. This drawing seems to be closest to a later painting, *Hamlet and Horatio,* now in the Louvre; the funeral procession in the background, which also appears in the painting, is missing from other preparatory works. (See the thorough discussion of this subject by R. I. Edenbaum: "Delacroix's Hamlet Studies," *Art Journal* 26 (1967), pp. 340–51.) Accordingly, this drawing may be dated between 1843 and 1859.

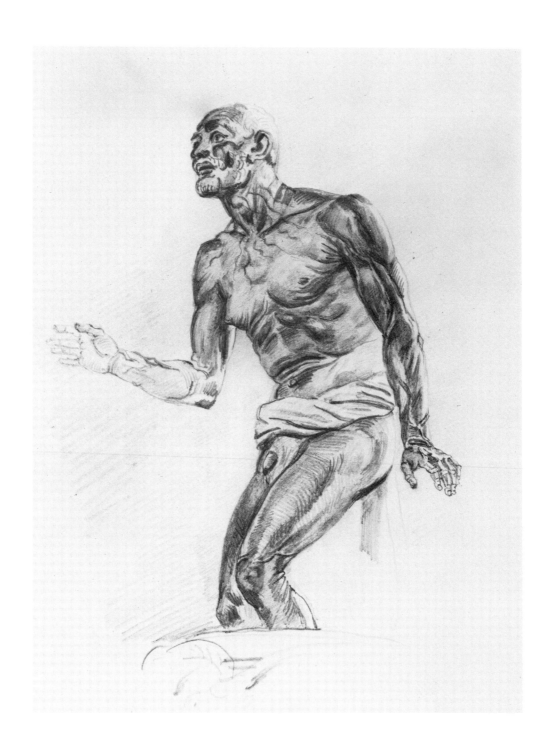

FERDINAND-VICTOR-EUGÈNE DELACROIX, Charenton, Paris, 1798–1863

36. *Study for "The Suicide of Seneca"*

Pencil on paper, 30.5 x 23.5 cm. Stamped with studio stamp in lower right corner: *E.D.*

BIBLIOGRAPHY: A. Robault and E. Chesneau, *L'Oeuvre complet de Eugène Delacroix*, New York, 1969, no. 882(?); Anderson Galleries, *Etchings, Lithographs, Original Drawings, The Collection of Marius de Zayas*, New York, May, 1920, no. 49.

This drawing is probably a study for Delacroix's painting of 1844. It has also been suggested that the artist was inspired by a marble statue in the Louvre known as *The Black Slave* (A. Robault and E. Chesneau, *L'Oeuvre complet*, no. 882).

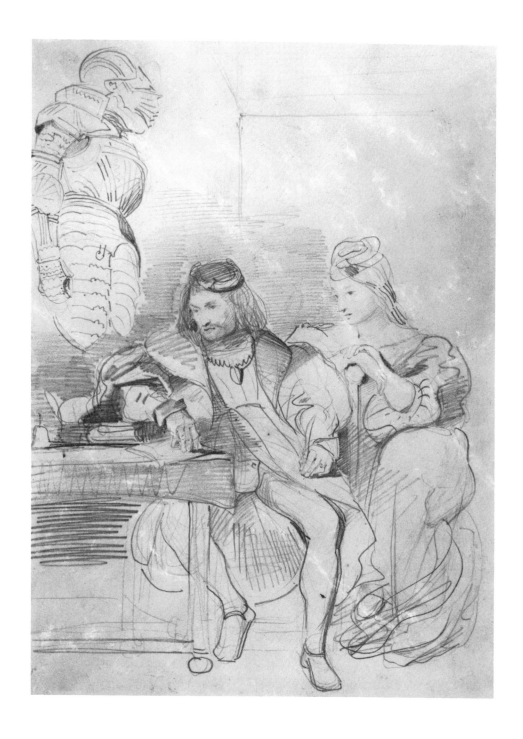

FERDINAND-VICTOR-EUGÈNE DELACROIX, Charenton, Paris, 1798–1863

37. A Scene from Goethe's "Goetz von Berlichingen"

Pencil on paper, 25.4 x 19 cm.

BIBLIOGRAPHY: A. Robault and E. Chesneau, *L'Oeuvre complet de Eugène Delacroix*, New York, 1969, no. 643; *Tricolour*, no. 73.

Delacroix was especially fond of the dramatic works of Shakespeare and Goethe. He prepared detailed studies and preliminary drawings for his lithographic illustrations of their works, paying great attention to details of costume and armor, as is evident in this sheet.

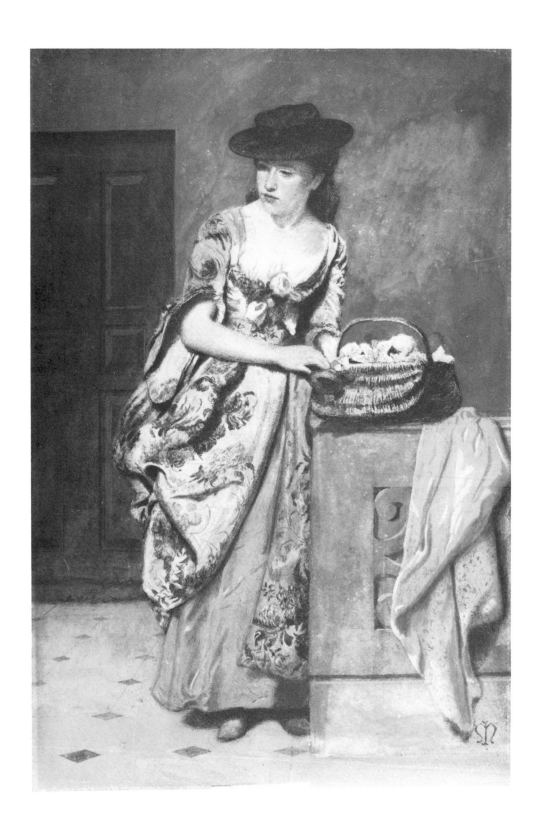

NARCISSE VIRGILE DIAZ DE LA PEÑA, Bordeaux, Paris, Mentone, 1808–1876

38. *Young Peasant Woman*

Watercolor and gouache on paper, 30.5 x 20.4 cm.

Unpublished.

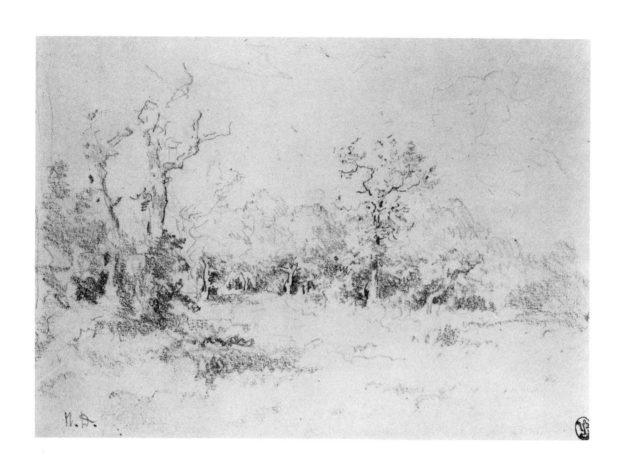

NARCISSE VIRGILE DIAZ DE LA PEÑA, Bordeaux, Paris, Mentone, 1808–1876

39. *Wooded Landscape*

Crayon on paper, 15 x 21.3 cm. Signed in lower left corner: *N.D.*

Unpublished.

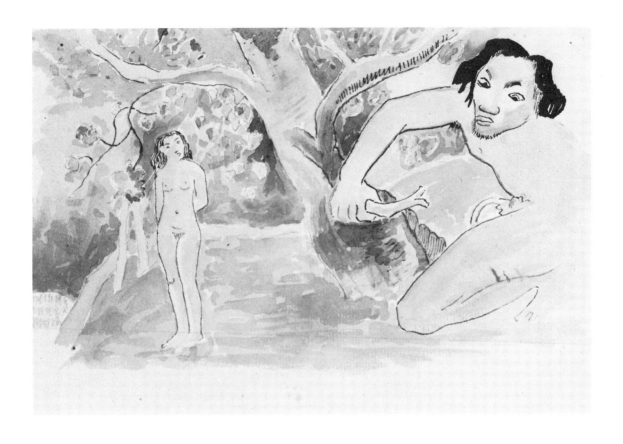

PAUL GAUGUIN, Paris, Pont-Aven, Tahiti, Fatu-Iwa, Marquesas Islands, 1848–1903

40. *Hiro and the Virgin*

Watercolor and pen on paper, 15 x 24 cm. Inscribed on the verso: *Hors texte de Noa Noa en duplicata que Gauguin envoya à mon père avec diverses aquarelles et dessins destinés à figurer dans le manuscrit…[Agnes]DE MONFREID.*

BIBLIOGRAPHY: Paul Gauguin, *Noa Noa—Voyage à Tahiti*, facsimile edition, Stockholm, 1947, p. 57; Paris, no. 134; J. Rewald, *Gauguin Drawings*, New York, 1958, pl. 81; Cincinnati, no. 288; Haus der Kunst, *Paul Gauguin*, exhibition catalogue, Munich, 1960, no. 106, fig. 62.

The inscription refers to Gauguin's account of his life in Tahiti, which was to have been published by Daniel de Monfreid. The watercolor is usually dated to between 1891 and 1893.

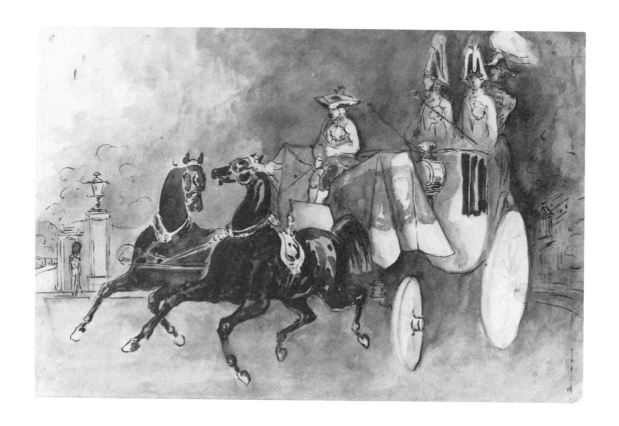

ERNEST-ADOLPHE-HYACINTHE-CONSTANTIN GUYS, Flushing (Holland), Paris, 1802–1892

41. *Equipage*

Pen and ink with watercolor on light brown paper, 28.2 x 41.3 cm.

BIBLIOGRAPHY: Cincinnati, no. 278; *Tricolour*, no. 76.

Judging from the costumes of the coachmen, footmen, and the master of ceremonies, this watercolor must have been painted in England in the late 1840s. This sheet is also an expression of the artist's love of horses.

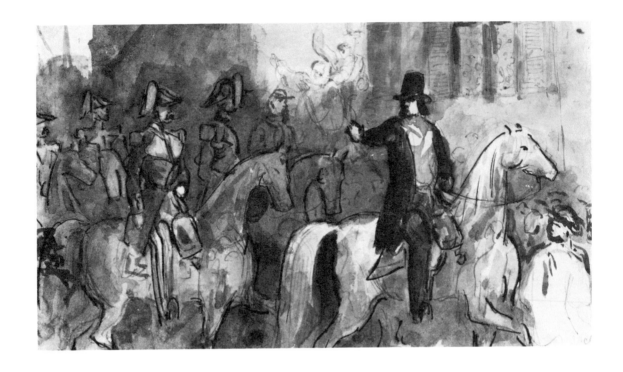

ERNEST-ADOLPHE-HYACINTHE-CONSTANTIN GUYS, Flushing (Holland), Paris,
1802–1892

42. *Napoleon on the Second of December, 1851*

Watercolor, gouache, and ink on paper, 16 x 29.5 cm.

BIBLIOGRAPHY: *Tricolour,* no. 77.

Guys often recorded events and scenes of contemporary life in quick watercolor sketches,
working like a newspaperman writing against a deadline. This scene represents the coup
d'état of Charles Louis Bonaparte on December 2, 1851. A year later he reestablished the
Empire and became Napoleon III.

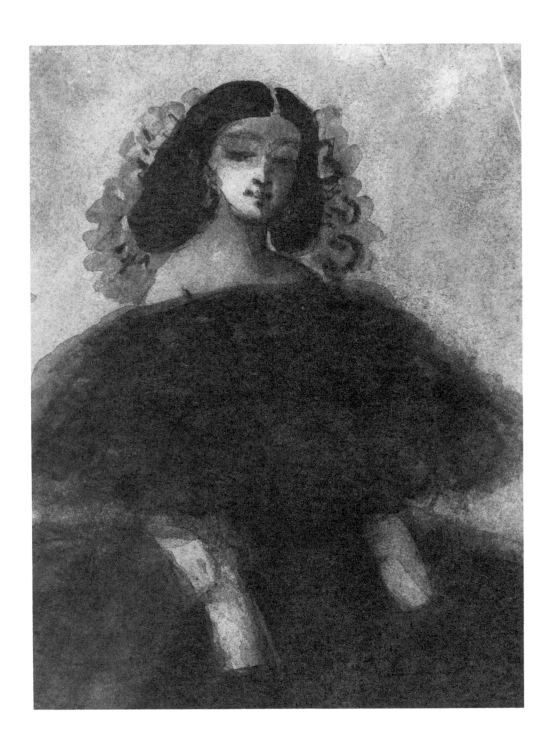

ERNEST-ADOLPHE-HYACINTHE-CONSTANTIN GUYS, Flushing (Holland), Paris, 1802–1892

43. *Young Woman in Blue and Black Dress*

Watercolor on paper, 21.5 x 17 cm.

BIBLIOGRAPHY: *Au temps de Baudelaire, Guys et Nadar,* Paris, 1945, no. 99; *Tricolour,* no. 79.

Most of Guys's drawings and watercolors are unsigned and undated. However, on the basis of the mature style and the virtuoso handling of the colors, this drawing may be placed in the 1870s.

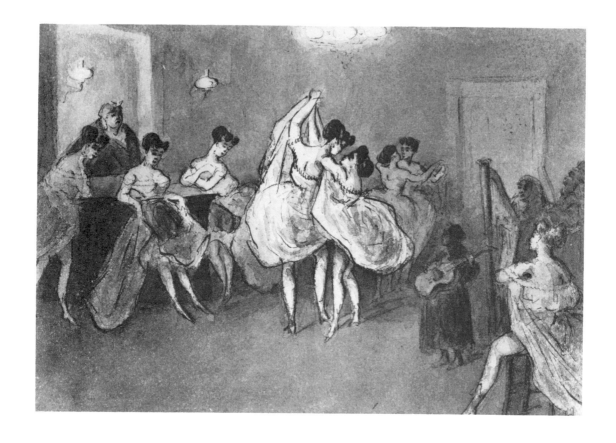

ERNEST-ADOLPHE-HYACINTHE-CONSTANTIN GUYS, Flushing (Holland), Paris,
1802–1892

44. *Dancing Women*

Pen and ink with wash on paper, 16.8 x 24.5 cm.

BIBLIOGRAPHY: *Tricolour,* no. 75.

The costume and the somewhat weak pen strokes indicate a date after 1870. The impover-
ished artist was forced to frequent the lower-class dance halls and cabarets in his search for
subjects (C. Hill and L. Browse, *Constantin Guys*, London, 1946, pp. 13–14).

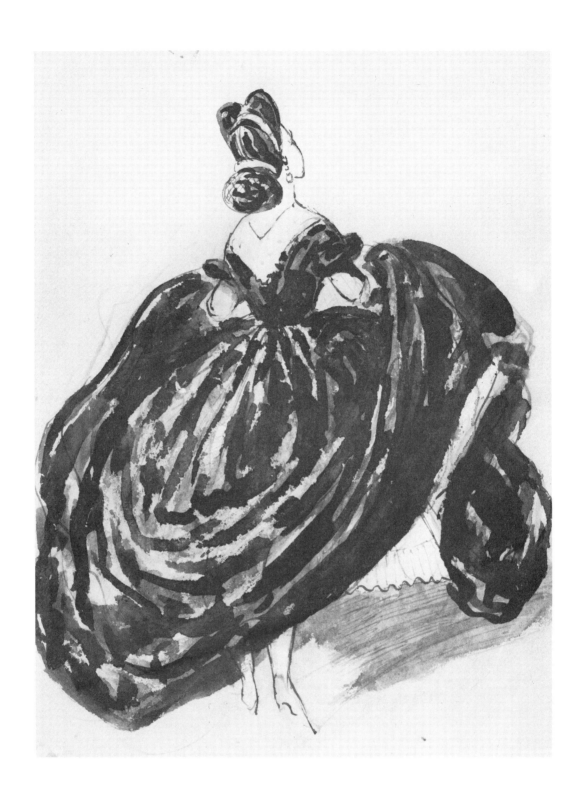

ERNEST-ADOLPHE-HYACINTHE-CONSTANTIN GUYS, Flushing (Holland), Paris, 1802–1892

45. *Parisienne Seen from the Back*

India ink with pen and brush on paper, 24.8 x 18.5 cm.

BIBLIOGRAPHY: *Tricolour,* no. 78.

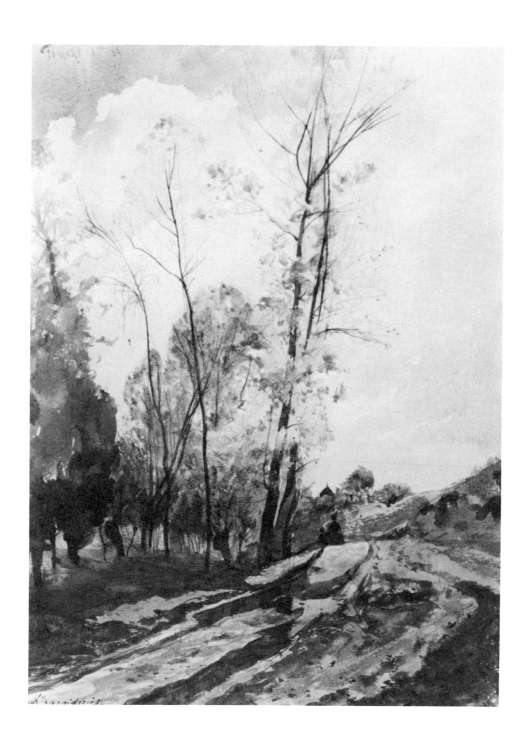

HENRI-JOSEPH HARPIGNIES, Valenciennes, Paris, Saint-Privé (Yonne), 1819–1916

46. *Landscape*

Watercolor over pencil on paper, 32.5 x 23.7 cm. Signed in lower left corner: *H. Harpignies*. Inscribed in upper left corner: *FAMARS 8 bre 63*.

Unpublished.

The inscription dates the drawing to October, 1863. Apparently it depicts two figures walking on the winding road near Famars, the small town where the artist's father was part owner of a sugar factory (See Musée des Beaux-Arts, *Henri Harpignies*, exhibition catalogue, Valenciennes, 1970, p. 2).

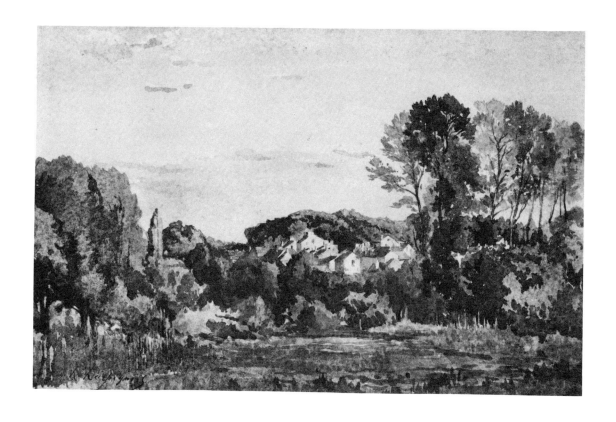

HENRI-JOSEPH HARPIGNIES, Valenciennes, Paris, Saint-Privé (Yonne), 1819–1916

47. *Landscape with Distant Town*

Watercolor on paper, 23.8 x 38.1 cm. Signed in lower left corner: *h. harpignies*.

BIBLIOGRAPHY: *Tricolour,* no. 80; *French Watercolor Landscapes*, no. 73.

The entire oeuvre of the artist was influenced by Camille Corot, as is evident from this sheet, which may date from the 1870s.

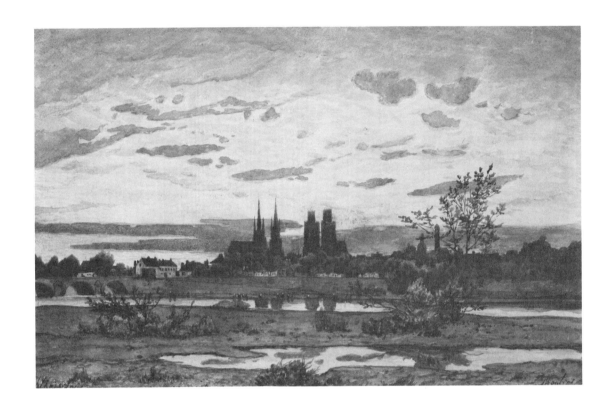

HENRI-JOSEPH HARPIGNIES, Valenciennes, Paris, Saint-Privé (Yonne), 1819–1916

48. *Moulins*

Watercolor on paper, 30.5 x 50.8 cm. Signed in lower left corner: *h. harpignies.* Inscribed at lower right: *Moulins.*

BIBLIOGRAPHY: *French Watercolor Landscapes*, no. 74.

The sweeping view and the brilliant colors are full expressions of Harpignies's mastery of landscape and the watercolor medium. The mature style places this drawing in the 1880s.

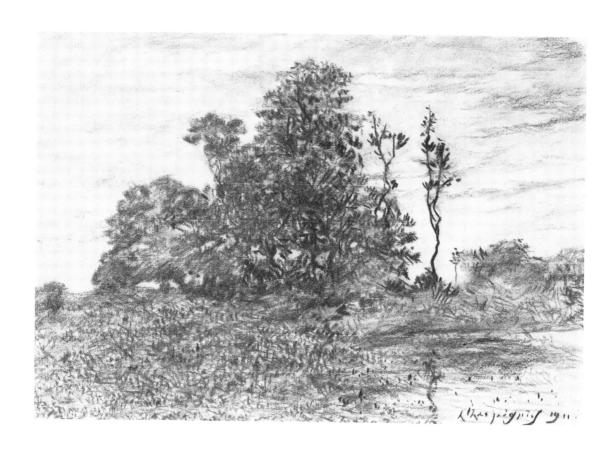

HENRI-JOSEPH HARPIGNIES, Valenciennes, Paris, Saint-Privé (Yonne), 1819–1916
49. *The Pond—Les Luneaux, Allier*
Charcoal on paper, 29.8 x 44.5 cm. Signed and dated at lower right: *H. Harpignies*, 1911.
BIBLIOGRAPHY: Jacques Seligman & Co., Inc., *Master Drawings*, New York, November, 1964, no. 19.

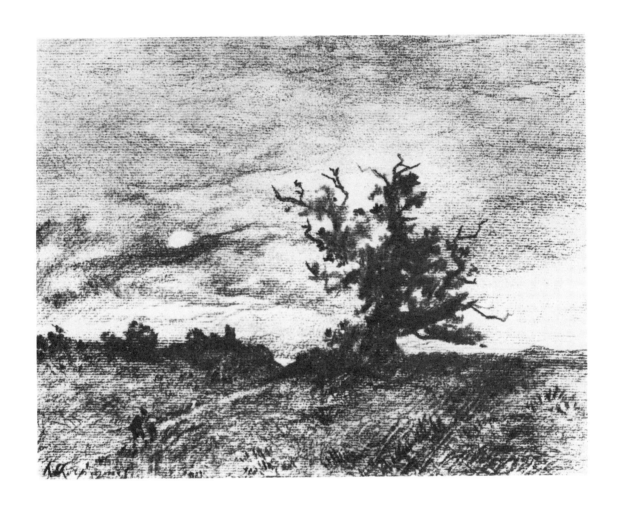

HENRI-JOSEPH HARPIGNIES, Valenciennes, Paris, Saint-Privé (Yonne), 1819–1916

50. *Moonlit Landscape*

Charcoal on paper, 22.2 x 29.2 cm. Signed at lower left: *h. Harpignies*.

BIBLIOGRAPHY: Jacques Seligman & Co., Inc., *Master Drawings*, New York, November, 1962, no. 20.

It seems that the artist did not make much use of charcoal until toward the end of his life. This powerful landscape, therefore, may be dated around 1910.

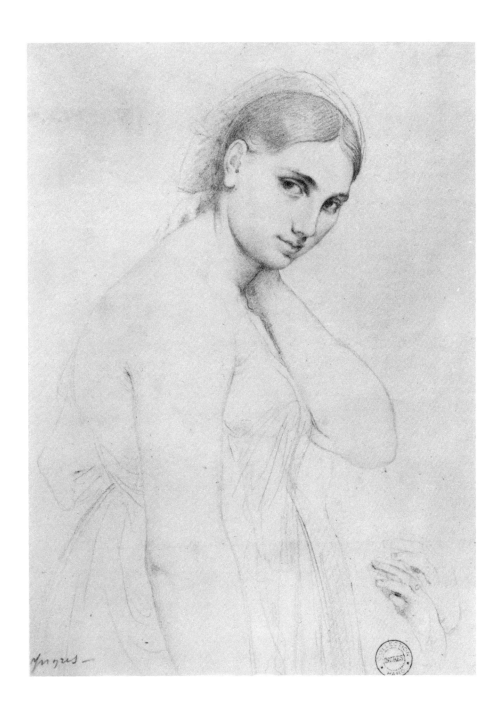

JEAN-AUGUSTE-DOMINIQUE INGRES, Montauban, Rome, Paris, 1780–1867

51. *Study for "Raphael and the Fornarina"*

Graphite on white wove paper, 25.4 x 19.7 cm. Signed in lower left corner: *Ingres—*.

BIBLIOGRAPHY: Paris, no. 140; Cincinnati, no. 277; Paul Rosenberg & Co., *Ingres in American Collections*, exhibition catalogue, New York, 1961, no. 13; Fogg Art Museum, *Ingres Centennial Exhibition 1867–1967*, Cambridge, Mass., 1967, no. 25; A. Mongan, "Ingres as a Great Portrait Draughtsman," *Colloque Ingres*, Montauban, 1967, p. 144, fig. 14.

This exquisite drawing is closely related to the painted *Raphael and Fornarina* in the Fogg Museum in Cambridge, Mass., which is the earliest surviving version out of an original five. The painting is dated 1813 and was exhibited at the Salon of 1814. The drawing may therefore be dated around 1813.

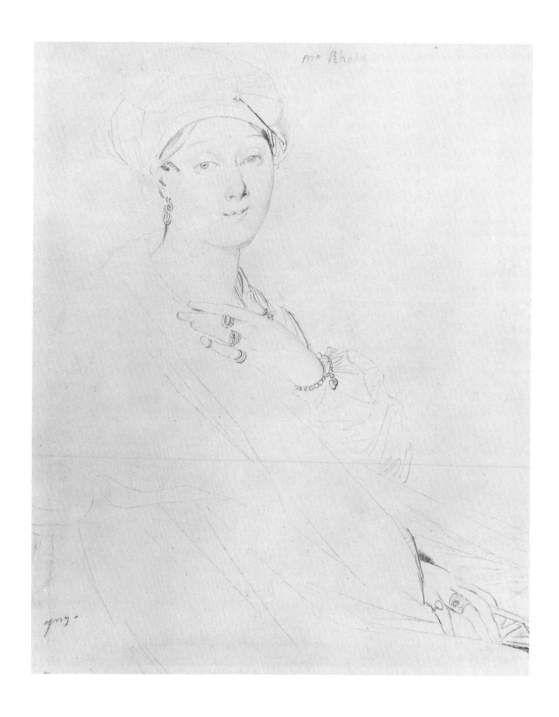

JEAN-AUGUSTE-DOMINIQUE INGRES, Montauban, Rome, Paris, 1780–1867

52. *Madame Rhode(?)*

Graphite on white paper, 15.6 x 11.7 cm. Signed at lower left: *Ing—*. Inscribed at top center: *M^e Rhod…*

BIBLIOGRAPHY: H. Delaborde, *Ingres, sa vie, ses travaux, sa doctrine*, Paris, 1870, no. 241; H. Lapauze, *Ingres, sa vie et son oeuvre*, Paris, 1911, p. 122; H. Naef, "Ingres' Portrait Drawings of English Sitters in Rome," *Burlington Magazine* 98 (1956), p. 432, fig. 12; C. G. Heise, *Grosse Zeichner des 19. Jahrhunderts*, Berlin, 1959, pp. 79–80; Paris, no. 318; Cincinnati, no. 275.

The reading of the name at the top is still uncertain. Hans Naef, the eminent Ingres scholar, thinks this might be the portrait of an English lady, a Mrs. Rawdon. It may be dated to between 1806 and 1820.

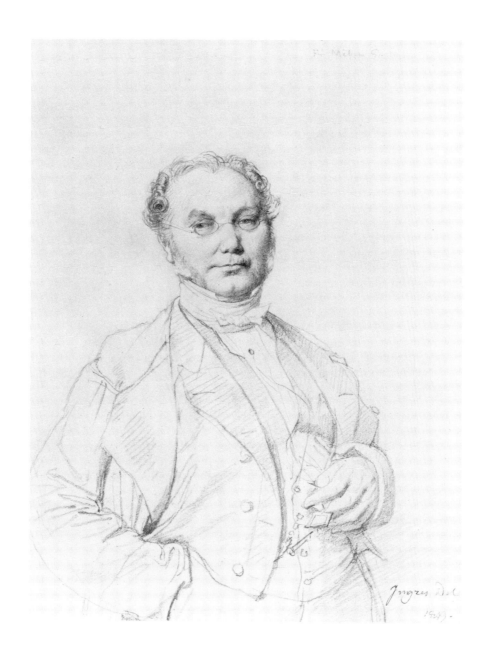

JEAN-AUGUSTE-DOMINIQUE INGRES, Montauban, Rome, Paris, 1780–1867

53. *Portrait of Dr. François Melier*

Graphite on white wove paper heightened with white, 24.2 x 18.1 cm. Signed and dated at lower right: *Ingres Del 1849*. Inscribed at upper right: *F.s. Melier D..M.*

BIBLIOGRAPHY: Paul Rosenberg & Co., *Ingres in American Collections*, exhibition catalogue, New York, 1961, no. 63; H. Naef, "Zwei unveröffentlichte Ingres-Zeichnungen," *Pantheon* 19 (1961), pp. 80–81.

Dr. François Melier (1789–1866) was an eminent French physician and a pioneer in public health care. As he stated in 1827: "Médecine publique...devient une véritable science sociale" (see H. Naef, "Zwei unveröffentlichte Ingres-Zeichnungen," p. 80).

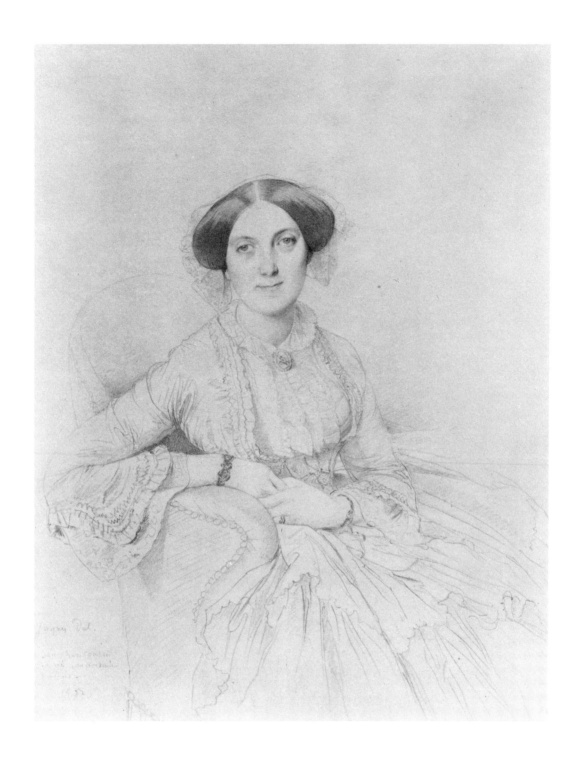

JEAN-AUGUSTE-DOMINIQUE INGRES, Montauban, Rome, Paris, 1780–1867

54. *Madame Félix Gallois*

Graphite on white wove paper with touches of watercolor, 34.6 x 26.8 cm. Signed, inscribed, and dated in lower left corner: *J. Ingres Del. à son cher cousin et ami Monsieur Gallois—1852.*

BIBLIOGRAPHY: Fogg Art Museum, *Ingres Centennial Exhibition 1867–1967*, Cambridge, Mass., 1967, no. 100.

Ingres was related to the Gallois family through his marriage to Delphine Ramel. Here the use of light watercolor to accentuate the jewelry is noteworthy.

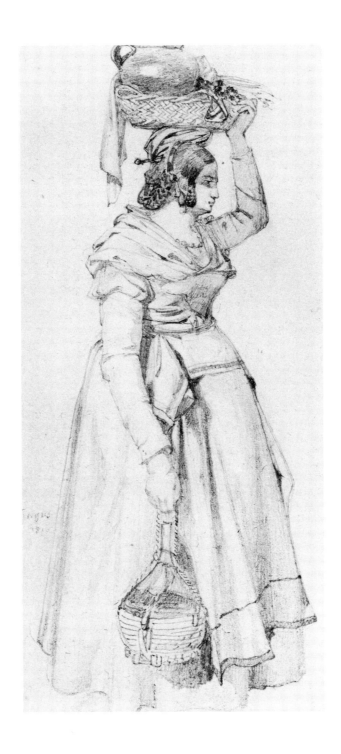

ATTRIBUTED TO JEAN-AUGUSTE-DOMINIQUE INGRES, Montauban, Rome, Paris, 1780–1867

55. *Peasant Woman with Basket on her Head*

Graphite on paper, 25.7 x 12.3 cm. Inscribed at left: *Ingres 1810*.

Unpublished.

The attribution to Ingres and the authenticity of the signature are questionable. Agnes Mongan has suggested in a written communication that the drawing might be by the French artist Louis-Léopold Robert (1794–1835), who lived in Rome from 1818 to 1832.

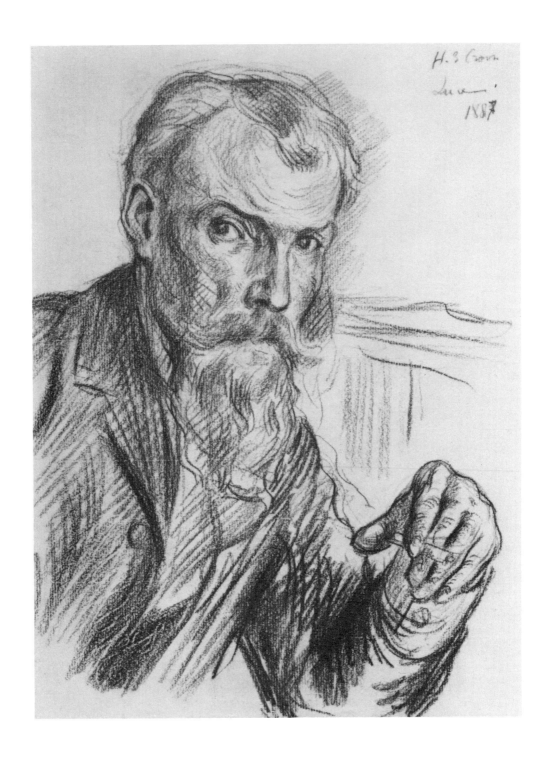

MAXIMILIAN LUCE, Paris, 1858–1941

56. *Portrait of Henri-Edmond Cross*

Pencil on paper, 30.5 x 23 cm. Inscribed, signed, and dated in upper right corner: *H.E. Cross Luce 1887.*

BIBLIOGRAPHY: *Paris: Places and People*, no. 37.

The work of H.-E. Cross (Delacroix) is represented in this exhibition by eight drawings (Nos. 19–26).

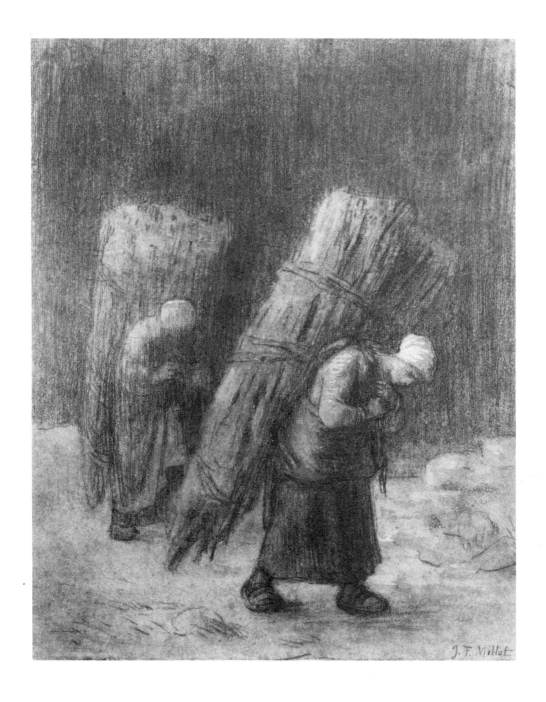

JEAN-FRANÇOIS MILLET, Gruchy, Paris, Barbizon, 1814–1875

57. *The Faggot Gatherers*

Charcoal with slight heightening in white gouache, 34.2 x 27.7 cm. Signed in ink in lower right corner: *J.F. Millet.*

BIBLIOGRAPHY: E. Moreau-Nelaton, *Millet raconté par lui-même*, vol. I, Paris, 1921, pp. 36–37; *Tricolour*, no. 81.

This powerful and dramatic drawing is a carefully executed final study for the artist's great oil painting, *The Faggot Gatherers*, of 1858 (Hermitage Museum, Leningrad, no. 3924). The two compositions are identical, and the drawing expresses in the same forceful way the artist's representation of "la triste condition humaine, la fatigue" (E. Moreau Nelaton, *Millet raconté*, pp. 90–91).

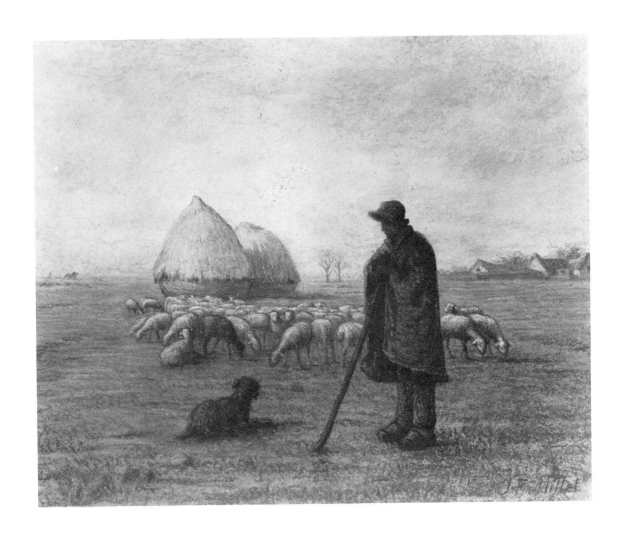

JEAN-FRANÇOIS MILLET, Gruchy, Paris, Barbizon, 1814–1875
58. *Shepherd and His Flock*
Pastel on paper, 25.4 x 31.1 cm. Inscribed in lower right corner: *J.F. Millet.*
BIBLIOGRAPHY: *Tricolour*, no. 82.

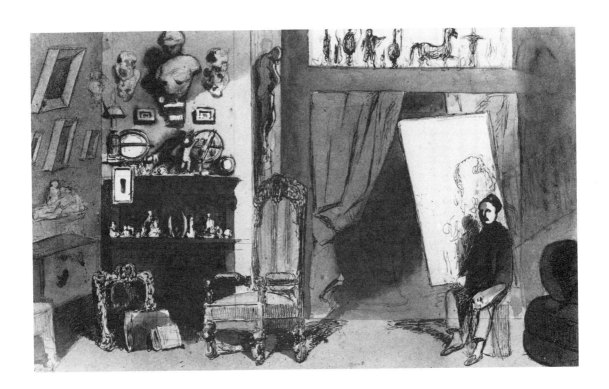

HENRI-BONAVENTURE MONNIER, Paris, 1805–1877

59. *A Painter's Studio*

Pen and ink with colored washes on paper, 19 x 29.5 cm.

BIBLIOGRAPHY: A. Marie, *L'Art et la vie romantiques: Henri Monnier*, Paris, 1931, p. 281; *Tricolour*, no. 83.

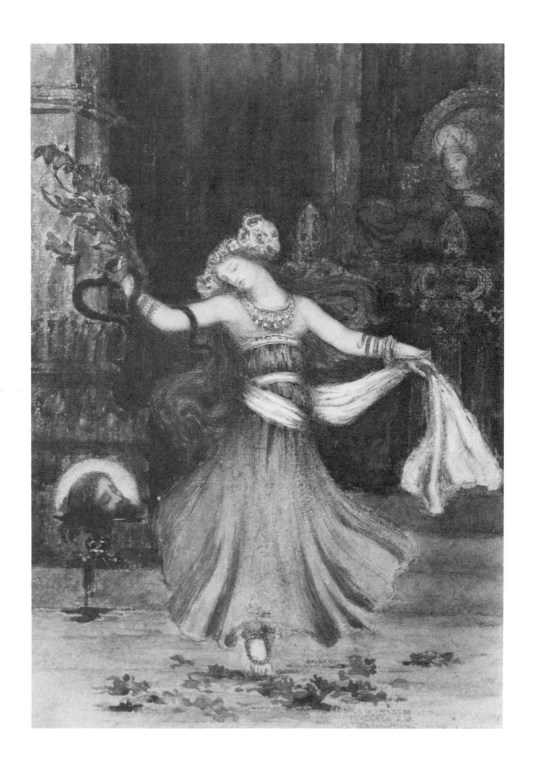

GUSTAVE MOREAU, Paris, 1826–1898

60. *Salomé Dancing Before the Head of St. John the Baptist*

Watercolor and gouache on paper, 24.1 x 17.2 cm.

BIBLIOGRAPHY: *Tricolour*, no. 84.

Various compositions treating the story of Salomé occupied the artist in the mid-1870s. We may assume that this watercolor was made during that decade (see J. Kaplan, *Gustave Moreau*, exhibition catalogue, Los Angeles County Museum of Art, 1974, pp. 34–41).

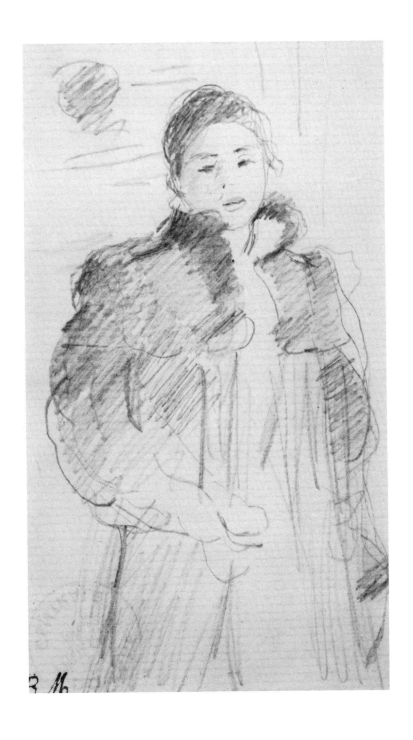

BERTHE-MARIE-PAULINE MORISOT, Bourges, Paris, 1841–1895

61. *Study for "Girl in a Green Coat"*

Pencil on paper, 17.5 x 10.2 cm. Inscribed in ink with initials: *B.M.*

BIBLIOGRAPHY: Charles E. Slatkin Galleries, *Berthe Morisot Drawings, Pastels, Watercolors, Paintings*, exhibition catalogue, New York, 1960, no. 142; *Tricolour*, no. 85.

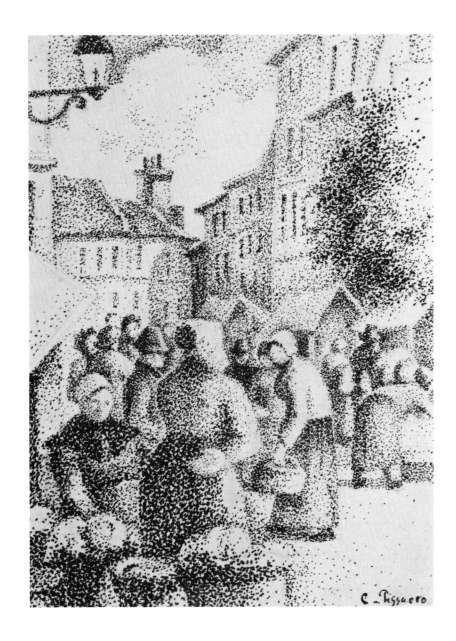

CAMILLE PISSARRO, St. Thomas (West Indies), Paris, 1831–1903

62. *Market Place in Pontoise*

Pen and ink on paper, 16.8 x 12.7 cm. Signed in lower right corner: *C. Pissarro.*

BIBLIOGRAPHY: Wildenstein Galleries, *Seurat and His Friends*, exhibition catalogue, New York, 1953, no. 91; J. Rewald, *Post-Impressionism from Van Gogh to Gauguin*, New York, 1956, p. 110; R. L. Herbert, *Neo-Impressionism*, New York, 1968, p. 83; R. Shikes and P. Harper, *Pissarro: His Life and Work*, New York, 1980, p. 211.

This drawing was executed in 1886 and is mentioned by the artist in a letter of December 30, 1886 (see R. L. Herbert, *Neo-Impressionism*, p. 83). It is one of only three drawings Pissarro did in the "dotted ink" technique (he onced remarked to his son that "the dot is still capable of frightening our charming bourgeois"). The spirited little vignettes were apparently meant to be published as illustrations, but there is no trace of their printed reproduction. The second of these dotted drawings is now in the Cabinet des Dessins of the Louvre, a gift of the late Max Kaganovitch of Paris. The third was offered to H. B. Manson by Lucien Pissarro, the artist's son, but its present whereabouts are not known.

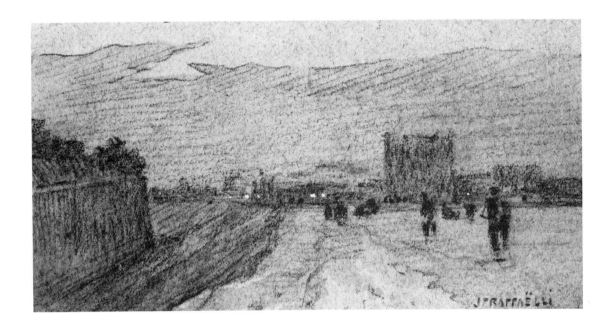

JEAN-FRANÇOIS RAFFAELLI, Paris, 1850–1924

63. *Landscape with Road Approaching the City*

Charcoal and white paint on gray paper, 8.3 x 15.9 cm. Signed at lower right: *J.F. RAFFAELLI.*
Unpublished.

This haunting little landscape is probably from the late 1870s. At that time Raffaelli was
deeply involved in depicting the suburbs of Paris; this drawing probably represents the gas
tanks of industrial Clichy. In 1878 the critic J.-K. Huysmans said of the artist: "Raffaelli is one
of the few who has grasped the original beauty of these districts....It is a world apart, sad,
dreary, but for this very reason lonely and charming."

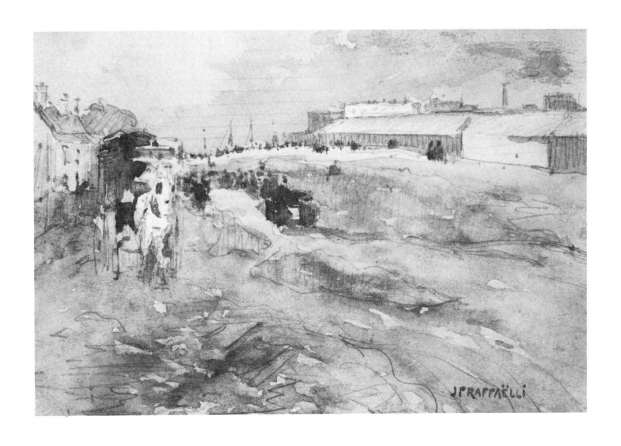

JEAN-FRANÇOIS RAFFAELLI, Paris, 1850–1924

64. *Suburban Landscape*

Watercolor over pencil on paper, 11.4 x 17.5 cm. Signed at lower right: *J.F. RAFFAELLI.*
Unpublished.

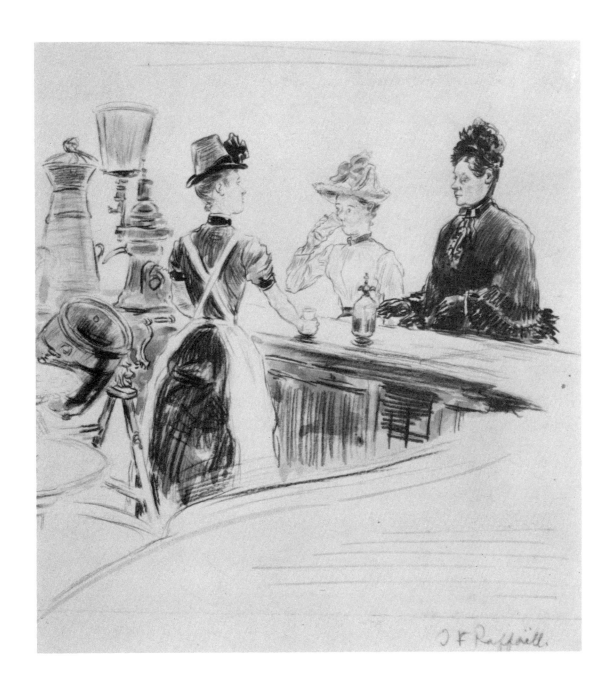

JEAN-FRANÇOIS RAFFAELLI, Paris, 1850–1924

65. *Women at the Counter*

Pencil on paper, 22 x 20 cm. Signed in lower right corner: *J.F. Raffaelli.*

BIBLIOGRAPHY: Hôtel Drouot, *Tableaux modernes...dessins...*, Paris, June, 1949, no. 55; *Paris: Places and People*, no. 41.

Judging from the costumes, the drawing is datable to the 1890s.

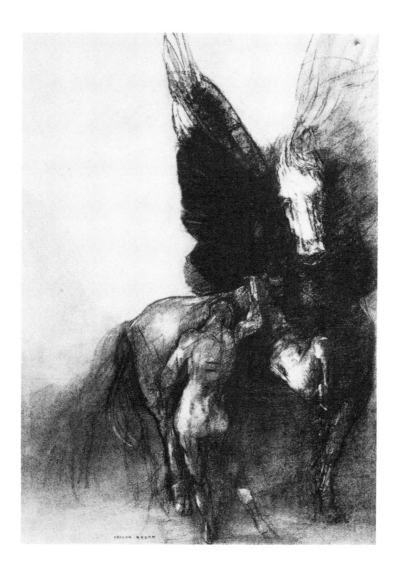

ODILON REDON, Bordeaux, Paris, 1840–1916

66. *Pegasus and Bellerophon*

Charcoal on buff paper, 53.7 x 35.9 cm. Signed at lower center: *ODILON REDON*.

BIBLIOGRAPHY: Museum of Modern Art, *Lautrec and Redon*, exhibition catalogue, New York, 1931, no. 95; H. Tietze, *European Master Drawings in the United States*, New York, 1947, no. 156; The Metropolitan Museum of Art, *French Drawings from American Collections: Clouet to Matisse*, exhibition catalogue, New York, 1959, no. 180; Museum of Modern Art, *Redon, Moreau, Bresdin*, exhibition catalogue, New York, 1961, no. 115; K. Berger, *Odilon Redon*, New York, 1965, p. 230.

The mythological figure of Pegasus apparently had special symbolic meaning for Redon. He described him in words almost as poetic as this drawing: "Pegasus, beautiful Pegasus, is the very incarnation of the Spirit; sometimes captive, sometimes free and airborne, he is the most highly evolved of beings, the chosen creature, the most lofty symbol" (R. Bacou, *Odilon Redon*, vol. I, Geneva, 1956, p. 66). Redon represented the winged horse in three lithographs of 1883, 1889, and 1893 and, later, in several paintings (A. Mellerio, *Odilon Redon*, Paris, 1923, nos. 51, 102, 122). This undated drawing seems to be closest to the 1889 lithograph and should be dated about the same time. However, it differs from all the other versions by emphasizing the figure of Bellerophon, thus creating a highly harmonious composition, brilliantly executed with the use of contrasting blacks and lights.

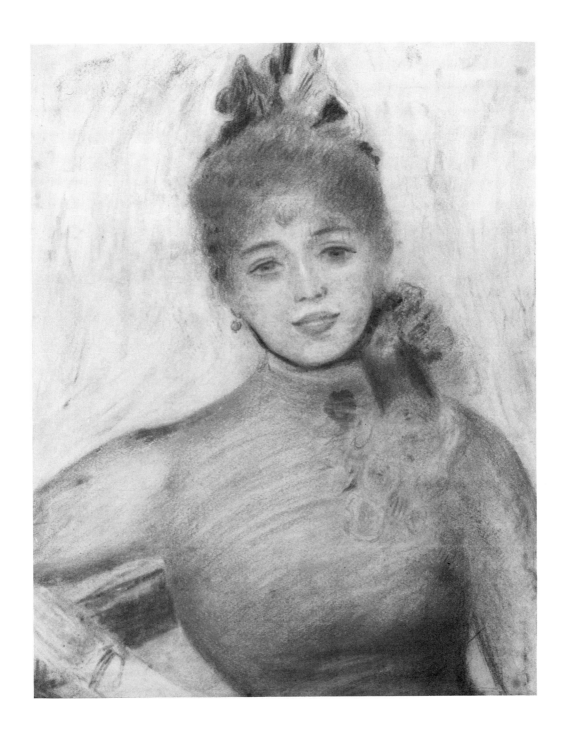

PIERRE-AUGUSTE RENOIR, Limoges, Paris, Cagnes-sur-Mer, 1841–1919

67. *Portrait of Madame Séverine*

Black crayon, charcoal, and white paint on paper, 59.7 x 46.4 cm.

BIBLIOGRAPHY: Paris, no. 142; Cincinnati, no. 286; *Paris: Places and People*, no. 26.

This sensitive portrait is probably a study for the artist's famous pastel in the Chester Dale Collection, National Gallery of Art, Washington, D.C. Séverine was the pen name of Caroline Rémy (1835–1892), one of the first prominent female journalists in France. This mellow and pensive image—which, according to some critics, is among the best French portraits, continuing the great tradition of Ingres—belies Madame Séverine's militant socialist politics.

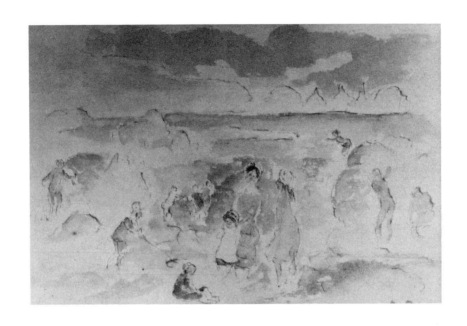

PIERRE-AUGUSTE RENOIR, Limoges, Paris, Cagnes-sur-Mer, 1841–1919

68. *Beach Scene*

Watercolor on paper, 7.5 x 11.4 cm. Initialed at lower right: *P.R.*

BIBLIOGRAPHY: Charles E. Slatkin Galleries, *Renoir, Degas: A Loan Exhibition of Drawings, Pastels, Sculptures*, New York, 1958, no. 70.

This is probably a study for the oil painting *Children at the Seashore, Guernsey*, in the Museum of Fine Arts, Boston.

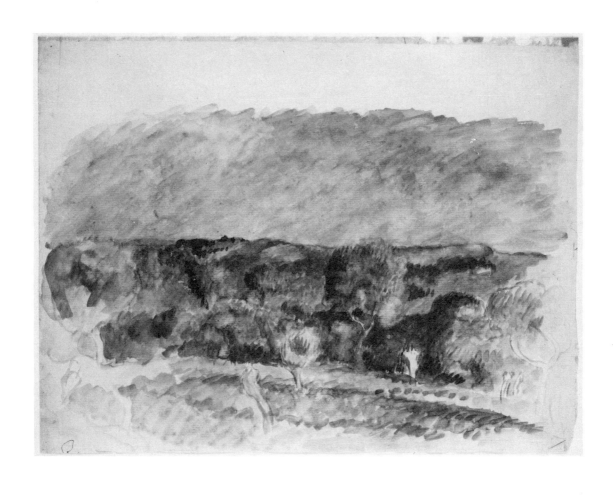

PIERRE-AUGUSTE RENOIR, Limoges, Paris, Cagnes-sur-Mer, 1841–1919
69. *Landscape with Figures*
Watercolor on paper, 21.9 x 30.1 cm. Initialed at lower left: *R*.
Unpublished.

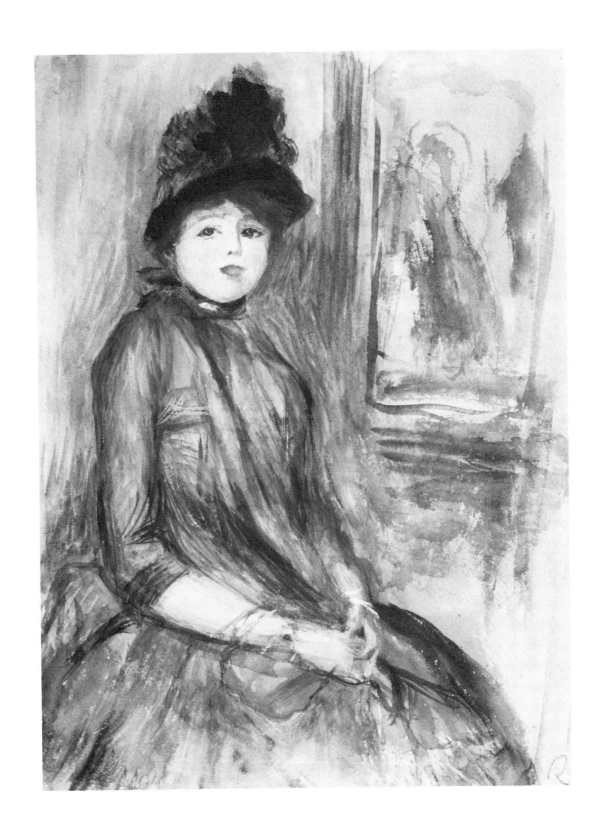

PIERRE-AUGUSTE RENOIR, Limoges, Paris, Cagnes-sur-Mer, 1841–1919

70. *Young Girl in a Blue Dress*
Watercolor on paper, 21 x 17.6 cm. Initialed at lower right: *R*.
BIBLIOGRAPHY: Knoedler Galleries, *A Collector's Exhibition*, New York, 1950, p. 13.

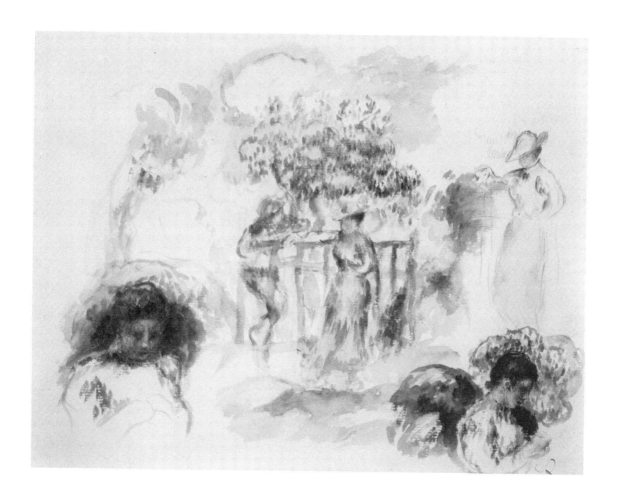

PIERRE-AUGUSTE RENOIR, Limoges, Paris, Cagnes-sur-Mer, 1841–1919

71. *Figures Under a Tree*

Watercolor on paper, 24 x 31 cm. Initialed at lower right: *R*.

BIBLIOGRAPHY: Charles E. Slatkin Galleries, *Renoir, Degas: A Loan Exhibition of Drawings, Pastels, Sculptures*, New York, 1958, no. 70; *Tricolour*, no. 87; *French Watercolor Landscapes*, no. 139.

Renoir was one of the very few Impressionist painters who used watercolors. Most of his experiments in the medium date from the 1870s and 1880s. This example may be dated to the end of the 1880s.

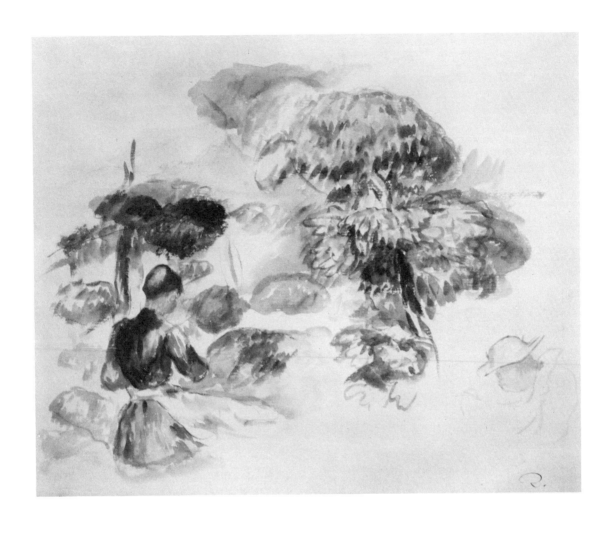

PIERRE-AUGUSTE RENOIR, Limoges, Paris, Cagnes-sur-Mer, 1841–1919

72. *Landscape with a Girl*

Watercolor on paper, 24.8 x 27.3 cm. Initialed at lower right: *R.*

BIBLIOGRAPHY: Charles E. Slatkin Galleries, *Renoir, Degas: A Loan Exhibition of Drawings, Pastels, Sculptures*, New York, 1958, no. 68.

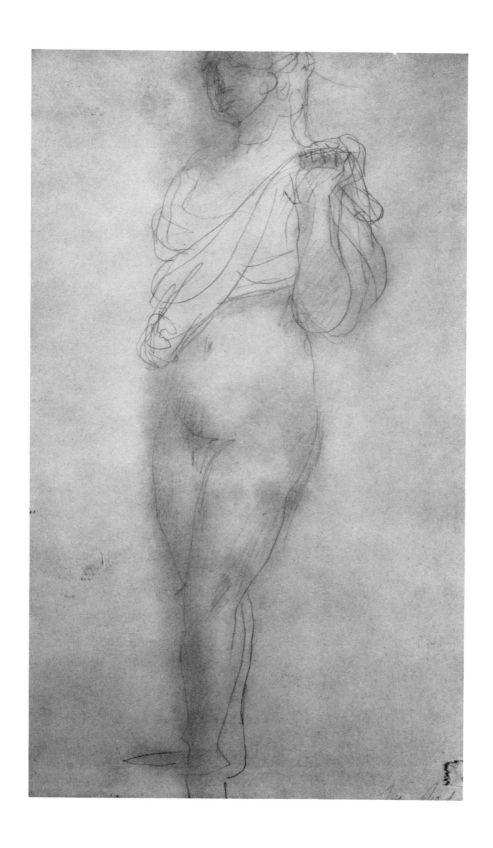

RENÉ-FRANÇOIS-AUGUSTE RODIN, Paris, Meudon, 1840–1917

73. *Study of a Nude with Drapery*

Pencil and bister on paper, 31 x 20 cm. Signed in lower right corner: *Aug. Rodin*.
Unpublished.

PIERRE-ÉTIENNE-THÉODORE ROUSSEAU, Paris, Barbizon, 1812–1867

74. *Autumn Landscape*

Ink and watercolor over pencil on paper, 13 x 21 cm. Stamped at lower right: *TH.R.*

BIBLIOGRAPHY: *Tricolour*, no. 88; *French Watercolor Landscapes*, no. 144.

A recent survey of nineteenth-century French watercolors dates this and similar "atmospheric" drawings after 1850 (*French Watercolor Landscapes*, p. 188).

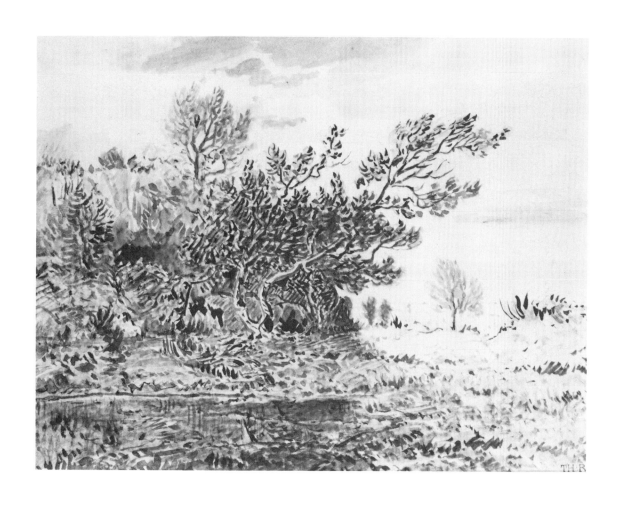

PIERRE-ÉTIENNE-THÉODORE ROUSSEAU, Paris, Barbizon, 1812–1867

75. *Landscape with a Pond*

Point of brush and ink with wash on paper, 13 x 17.7 cm. Stamped at lower right: *TH.R.*

BIBLIOGRAPHY: *Tricolour*, no. 89; *French Watercolor Landscapes*, no. 145.

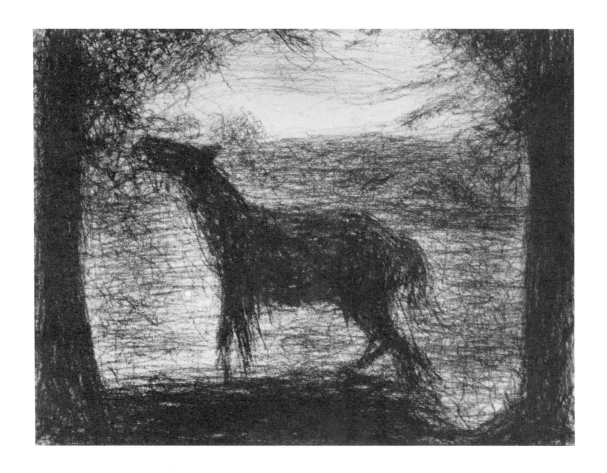

GEORGES SEURAT, Paris, 1859–1891

76. *The Colt*

Conté crayon on paper, 22.9 x 30.5 cm.

BIBLIOGRAPHY: Bernheim jeune, *Les Dessins de Georges Seurat*, Paris, n.d., no. 72; Paris, no. 145; C. M. de Hauke, *Seurat et son oeuvre*, Paris, 1961, no. 527; The Metropolitan Museum of Art, *Seurat, Drawings and Oil Sketches from New York Collections*, exhibition catalogue, New York, 1977, no. 12.

The catalogue raisonné of Seurat's work dates this drawing to about 1883 (C. M. de Hauke, *Seurat et son oeuvre*, p. 120).

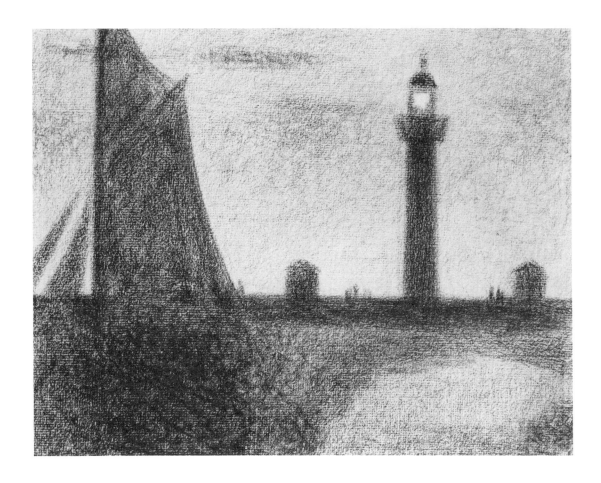

GEORGES SEURAT, Paris, 1859–1891

77. *The Lighthouse at Honfleur*

Conté crayon heightened with gouache on paper, 24 x 30.7 cm.

BIBLIOGRAPHY: Bernheim jeune, *Les Dessins de Georges Seurat*, Paris, n.d., no. 65; H. Tietze, *European Master Drawings in the United States*, New York, 1947, no. 149; C. M. de Hauke, *Seurat et son oeuvre*, Paris, 1961, no. 656; *Tricolour*, no. 90; The Metropolitan Museum of Art, *Seurat, Drawings and Oil Sketches from New York Collections*, exhibition catalogue, New York, 1977, no. 37.

This drawing is a study from around 1886 for the painting *End of the Jetty, Honfleur*, in the Rijksmuseum Kröller-Müller, Otterlo, and has a distinguished provenance. It was listed in the posthumous inventory of the artist's studio by Maximilien Luce. Afterward it passed from Seurat's family to the collection of Félix Fénéon, Paris.

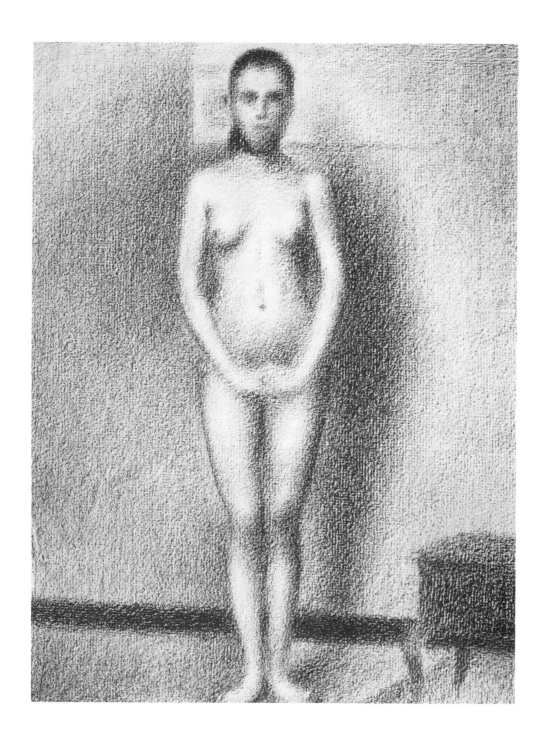

GEORGES SEURAT, Paris, 1859–1891

78. *Study for "Les Poseuses"*

Conté crayon on paper, 29.7 x 22.5 cm.

BIBLIOGRAPHY: Bernheim jeune, *Les Dessins de Georges Seurat*, Paris, n.d., pl. 99; Paris, no. 146; C. M. de Hauke, *Seurat et son oeuvre*, Paris, 1961, no. 664; The Metropolitan Museum of Art, *Seurat, Drawings and Oil Sketches from New York Collections*, exhibition catalogue, New York, 1977, no. 39.

This drawing is a well-known study for *Les Poseuses*, Seurat's painting of 1887–89 in the Barnes Foundation, Merion, Pennsylvania. The date could be as early as 1887, and the drawing is thus considered the *première pensée* for the figure.

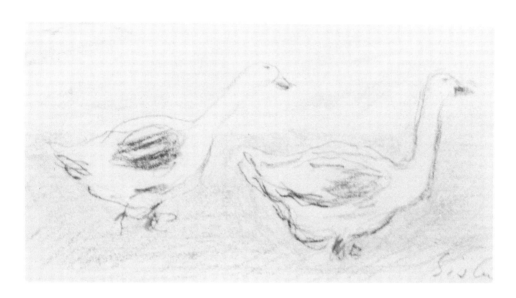

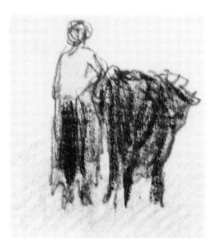 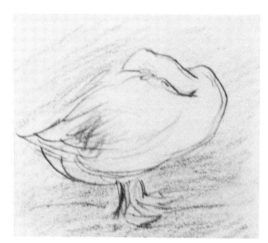

ALFRED SISLEY, Paris, Moret-sur-Loing, 1840–1899

79. *Three Sketches: Two Geese, Peasant Woman with a Cow, A Goose Hiding Its Head*

Pencil and colored crayon on paper, 7 x 13 cm., 6 x 5.5 cm., 6 x 7 cm. The largest sheet is signed at lower right: *Sisley.*

Unpublished.

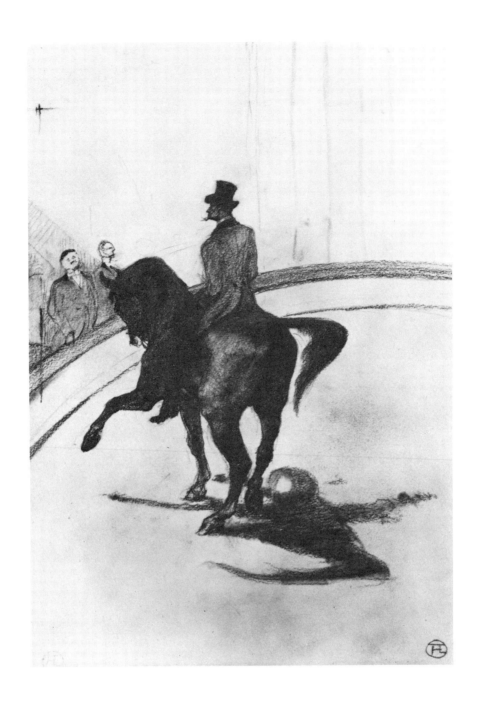

HENRI-MARIE-RAYMOND DE TOULOUSE-LAUTREC, Albi, Paris, Château de Malromé (Gironde), 1864–1901

80. *"Le Pas Espagnol"*

Black and colored crayons on paper, 35 x 25 cm. Signed at lower right with monogram: *HTL.* Stamped with studio stamp at lower left.

BIBLIOGRAPHY: M. Joyant, *Henri de Toulouse-Lautrec, 1864–1901: Dessins, estampes, affiches*, vol. II, Paris, 1927, p. 236, no. 15; Knoedler Galleries, *Collection of Pictures of Eric Maria Remarque*, exhibition catalogue, New York, 1943, no. 46; J. Edouard, *Toulouse-Lautrec at the Circus*, Paris, 1956, fig. 4; *Paris: Places and People*, no. 25.

The artist made an extensive series of crayon drawings with circus scenes in 1899. This composition is an integral part of the series and may be dated similarly.

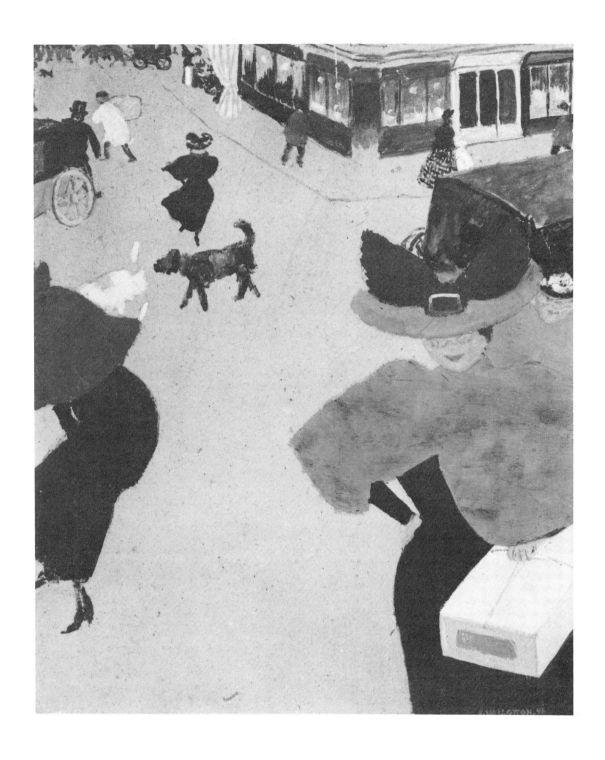

FÉLIX VALLOTTON, Lausanne, Paris, 1865–1925

81. *Street Scene in Paris*

Gouache on cardboard, 35.9 x 29.5 cm. Signed and dated at lower right: *F. VALLOTTON. 98.*
Unpublished.

WORKS ABBREVIATED

Cincinnati
Cincinnati Art Museum. *The Lehman Collection, New York*,
exhibition catalogue. Cincinnati, 1959.

Compin, *Cross*
Compin, Isabelle. *Henri-Edmond Cross*. Paris, 1964.

Degas in the Metropolitan
The Metropolitan Museum of Art. *Degas in the Metropolitan*,
exhibition catalogue. New York, 1977.

French Watercolor Landscapes
University of Maryland Art Gallery, *From Delacroix to
Cézanne: French Watercolor Landscapes of the Nineteenth Century*,
exhibition catalogue. College Park, Maryland, 1977.

Maison, *Daumier*
Maison, K. E. *Honoré Daumier: Catalogue Raisonné of the
Paintings, Watercolours, and Drawings*. 2 vols. Greenwich,
Conn., New York Graphic Society, 1968.

Paris
Musée de l'Orangerie. *Exposition de la collection Lehman de
New York*, exhibition catalogue. Paris, 1957.

Paris: Places and People
Bronx County Courthouse. *Paris: Places and People*, exhibi-
tion catalogue. New York, 1974.

Tricolour
Szabo, George. *Tricolour: Seventeenth Century Dutch, Eighteenth
Century English and Nineteenth Century French Drawings from the
Robert Lehman Collection*, exhibition catalogue. New York,
The Metropolitan Museum of Art, 1976.